IMAGES
of America

EARLY SAN JUAN COUNTY

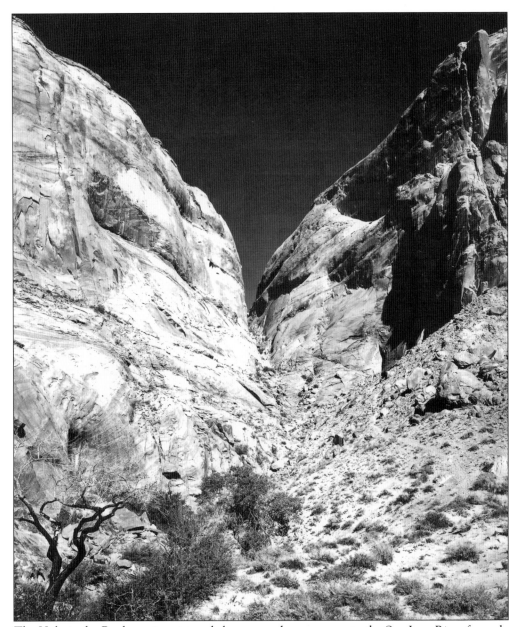

The Hole-in-the-Rock crevice pictured above served as a passage to the San Juan River for early pioneers. The crevice was far from where they stopped to create the community of Bluff. This photograph was taken before the formation of Lake Powell. It used to take two days of backpacking to visit the place. Today it is a two-hour boat ride to the foot of the climb.

ON THE COVER: This 1912 photograph shows the southern side of the San Juan Co-op building in Bluff, Utah. Pictured from left to right are unidentified, Harry Ranney, Frank Hyde, unidentified Ute Indian child at the wheel, Leland H. Redd, a Ute Indian named Tse-Ne-gat, and an unidentified child. Frances Nielson owned the first Model T Ford in Bluff, and he gave rides for 50¢. More people lined the streets of Bluff as it came into town than participated in a Fourth of July celebration. (Courtesy of the San Juan County Historical Society archives.)

IMAGES
of America

EARLY SAN JUAN COUNTY

LaVerne Tate and the
San Juan County Historical Society

ARCADIA
PUBLISHING

Published by Arcadia Publishing
Charleston SC, Chicago IL, Portsmouth NH, San Francisco CA

Printed in the United States of America

Library of Congress Catalog Card Number: 2008924292

For all general information contact Arcadia Publishing at:
Telephone 843-853-2070
Fax 843-853-0044
E-mail sales@arcadiapublishing.com
For customer service and orders:
Toll-Free 1-888-313-2665

Visit us on the Internet at www.arcadiapublishing.com

*This book is dedicated to all of my children,
who still love me after all the years of my "projects."*

CONTENTS

ACKNOWLEDGMENTS

Since its inception in April 1982, the San Juan County Historical Society has collected thousands of historical photographs, which have contributed greatly to our archives. All photographs in this publication, unless credited otherwise, are from our own archives. Many individuals have contributed to this collection and continue to donate images. I wish to acknowledge their valuable contributions. These great photographs have supported our publications and our county historical magazine, *Blue Mountain Shadows*, which is in its 22nd year of publication.

I am grateful to my colleagues at the San Juan County Historical Society; through the years, they have spent countless hours helping to collect, catalogue, and preserve these photographs. I work with Corinne Roring, Winston Hurst, Gary Guymon, and R. F. McDonald. I wish to acknowledge the ongoing work of R. F. McDonald, who digitized the historical collection. His knowledge of these avenues of preservation has been communicated freely. In 1943, my father, June Powell, brought my brother Jerry and me to Bluff to live. My widowed grandmother, May Powell, took all of us in and nurtured us. My knowledge of pioneer families and how they related to the old homes was a keen asset to me while writing this volume. My brother and I used to hike to the old swimming hole or a nearby canyon to climb around. My grandparents, Gene and May Powell, settled in Bluff in 1908 with their young family, and they lived the rest of their lives in Bluff. My knowledge of Native Americans, whom my family worked with in their trading post business, was helpful to me while writing this book.

I was given a window of time and an interested publisher with an editor who worked patiently with me. My years spent organizing historical photographs have contributed to the realization that some rare images in our collections were not previously available to the public.

I want to thank our San Juan County commissioners, Lynn Stevens, Kenneth Maryboy, and Bruce Adams, for their continued support of our historical projects and publications.

INTRODUCTION

No cameras were available to record the slow progress of the worn-out wagons and the dying cattle and pack mules of the San Juan Mission as its members traversed the last difficult miles to San Juan County. They stopped in Bluff, because they were too exhausted to move any farther, and they created the parent community for the entire area. The trek's details were engraved into the minds of those who made the journey through the Hole-in-the-Rock. Those stories were passed down as sacred tenants of their families' histories. Some of the group's members were aware of an abandoned mission called Elk Mountain Mission that entered the northern part of the county in 1855. They tried to settle near Moab, Utah. All but three of the men of the Elk Mountain Mission were massacred by Native Americans and driven off the land.

In the earliest years, gold was taken out of the sandbars of the lower San Juan River, and before the local people knew what was taking place, a gold rush ensued. Charles Goodman, a professional photographer, was among hundreds of prospectors who descended upon the town. Unlike the scores of prospectors who lost their hard-earned investments, Goodman brought the necessary means to support his interests. He was interested in slickrock canyon infernos and gold camps. He photographed the gold prospects they were seeking while traversing the canyons. He photographed mountain cattle camps, and he attended all community celebrations. His photographs recorded the times, places, and people of that first era, which has given us the history of the excitement starting in the 1890s. Many of the events, landmarks, buildings, and people have faded out of existence, but the vivid, descriptive images of his photographs provide the details. More than 100 of his photographs are included in this volume. San Juan is a large county today, but it was only a territory when it was first occupied. Since Utah became a state in 1896, women have always had the right to vote.

Scholars have unearthed Spanish exploring forages that went through the northern end of San Juan County, beginning with Rivera's records of 1785, which mention passing the sierra La Sal's on the eastern side and viewing the sierra Abajo (Blue) Mountain southwest. In the following two decades, more Spaniards passed on their way to trade with the Yuta Indians farther north.

Even though prosperous stockmen drove cattle into the grassland of the northern county, they were only interested in their vested ranching endeavors. Most of these groups came from Colorado and Texas to escape state taxes. They fattened their cattle and moved them out to the markets. In 1886 or shortly after, the Bluff settlers organized the Bluff Pool to combine their finances. They began a slow, successful, and organized effort to buy the cattle barons who were using up the grasslands of the county. One of the earliest assets was the San Juan Co-op store in Bluff. It was fortified by the gold-and-oil booms and was initially successful. A Texas outfit cattle drive moved onto the settler's rangeland on Elk Mountain. After much wrangling on both sides, the co-op bought them out. In 1888, a group of tenacious homesteaders associated with the Thomas Ray family settled in the area called Coyote (now known as La Sal).

The early settlers' spirit of industry and building is apparent in the area today, but this book shows the harsh conditions the settlers endured. Their contributions continue to motivate today's residents.

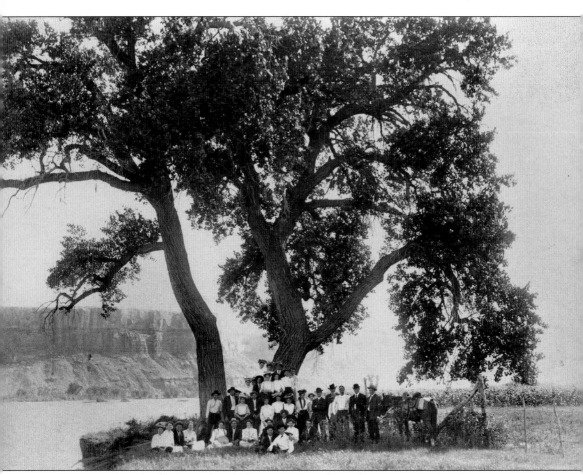

This *c.* 1894 photograph shows the Bluff Swing Tree, where the town's first church services were held until the log church was built. The site hosted many community affairs and picnics. On an ordinary, balmy summer evening, the young people gathered under its branches to fiddle, play guitars, and dance. Its huge branches offered relief from the hot, arid summers. The tree was later washed away in one of the floods the area experienced.

One

THE BLUFF FORT
AND EARLY CABINS

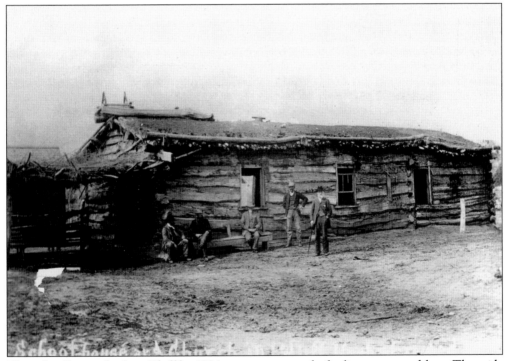

The schoolhouse, built in Bluff by 1884, was constructed of split cottonwood logs. The wide crevices were filled with mud. Rough split-log benches and a few slates with a potbellied stove were the sparse furnishings. All grade levels were taught in one room. Kumen Jones was appointed superintendent in 1880. The Church of Jesus Christ of Latter-day Saints services were held each Sunday in the building where all the community meetings and entertainment activities were held. From left to right in this photograph are the appointed church leaders, Kumen Jones, Platte D. Lyman, Jens Nelson, James B. Decker, and Francis A. Hammond.

The Wayne Redd cabin in Bluff is a typical example of the gnarled, uneven patterns that these cottonwood logs produced. In 1885, family members dragged logs, notched them, and then chinked the cracks. They hauled buckets full of red dirt for roofing to make it livable. From left to right in this photograph are Louie, Eva, Louisa E., and Frank Redd.

This photograph is of the Perry Allan cabin, which was located closer to the river on the southeast side of the Bluff community. Allan did not build his cabin originally. He came later than the first pioneers. One early journal states that Fletcher Hammond Sr. actually had the only shingle roof in the community. Earliest maps list both in the same area, and this photograph may record both homes in 1920. Fletcher was still living in Bluff in 1903.

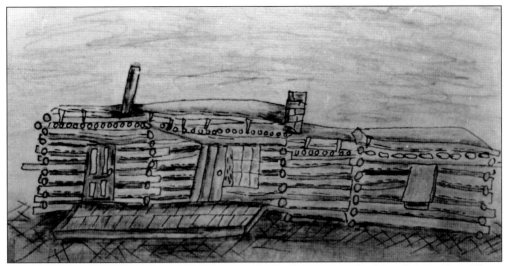

The Mormons who came through the Hole-in-the-Rock were not the first white settlers. Three Harris families had log cabins on small tracts of land in Bluff. Platte Lyman, who led the pioneer group into the valley of Bluff, bought George Harris's log house. His son, Albert R. Lyman, drew this replica of the log home in his journal in September 1896. He never mentions any other log home that they lived in.

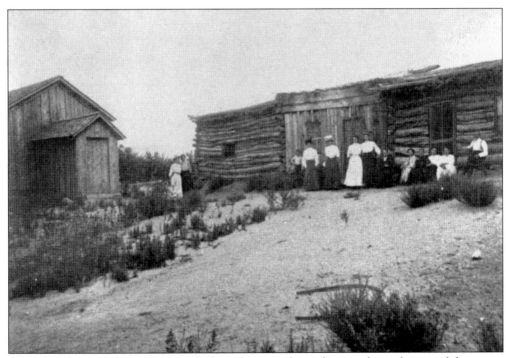

Samuel and Josephine "Jody" Wood's log cabin was the gathering place of many of the young people of the Bluff community. Samuel is on the far right of this 1892 photograph.

This 1907 photograph features the log home of Hyrum and Rachel Perkins. Rachel told her grandchildren the Perkins lived in the Bluff Fort in 1884 and the rain that started in March came down for several months. The children huddled under tables to stay dry, and the women carried umbrellas to do their work. Water poured through the sod roofs in muddy streams, which caused many people to stay wet and sick.

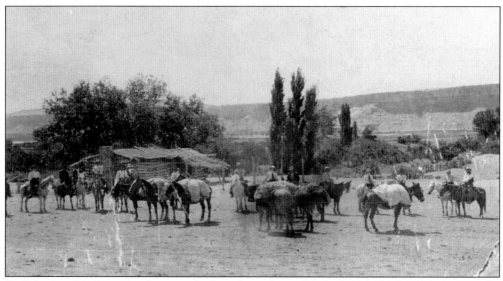

Built by Jens Nielson, this became the busy log cabin of Ezekiel "Zeke" Johnson, close to the San Juan River in Bluff. Zeke married Annetta Nielson, and this was their home in 1900. Zeke provided guide services and pack animals to the groups who came in during the gold-and-oil boom, taking groups to visit the Natural Bridges. He was the first custodian at the Natural Bridges National Monument, in 1908.

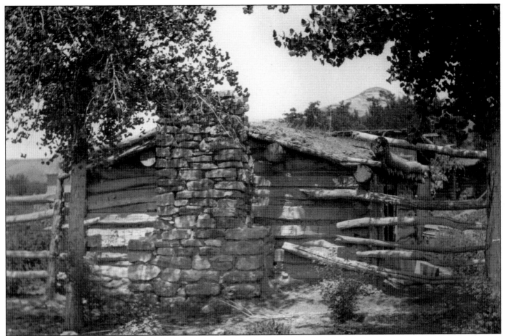

Pictured in 1902, this log home belonged to Joseph F. and Harriet Barton. It is the only original fort cabin still standing in Bluff. Stabilized by the San Juan County Historical Society, visitors can observe firsthand the rough-hewn lumber floors and log construction. Joseph F. Barton performed veterinarian services. Adelle Raplee owned the cabin when Barton died.

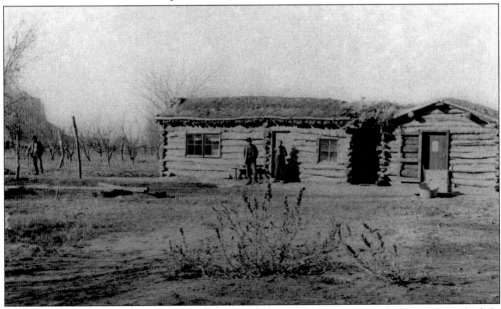

Peter Allan and his stepmother, Agnes, are pictured here about 1895 with John Allan, far left. The small building on the right was the first courthouse in San Juan County. In 1880, word was sent to new county members that the legislature had organized the new county and made appointments. Bluff served as the county seat for the next 13 years. La Sal homesteaders went to Bluff to file on their land.

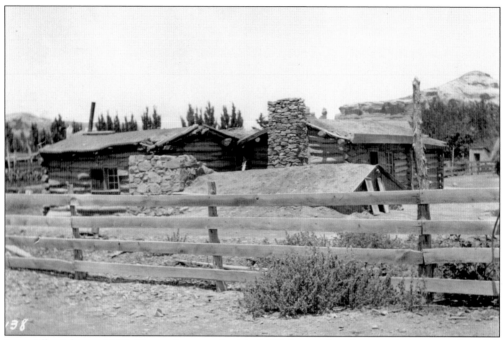

Jane Allan's home in Bluff was photographed in 1905. It was the place to obtain a meal in this remote outpost. Her meals were mentioned in field notes of famous expeditions, tourist groups, and among varied travelers. Wife of John Allan, they first settled at Montezuma Creek. The big flood of the San Juan River destroyed their home in Montezuma Creek in 1884.

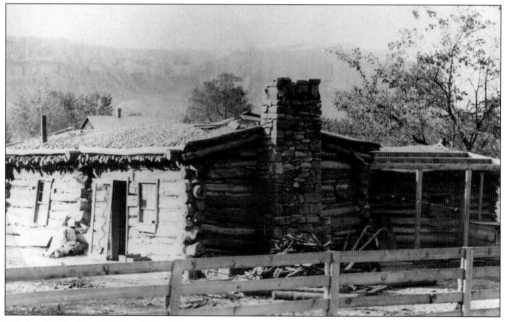

Thales Haskell built this Bluff cabin coming with the Hole-in-the-Rock company of 1880. After Haskell left for Colorado, L. H. Redd bought this cabin. Leland Redd was born here in 1884. Walter C. Lyman later rented or bought the cabin, as his son Lynn Lyman says he was born in the cabin in 1905.

14

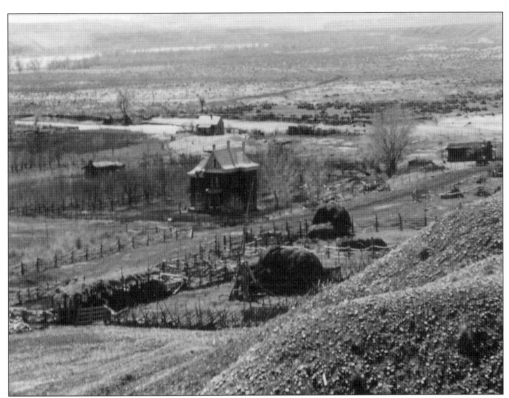

Charles Goodman's photograph, taken from the top of a nearby cliff, and Albert R. Lyman's earliest map identifies the homes on the west side of Bluff. The adobe brick home in the center belonged to James B. Decker. At left is the log home of John Adams, at the top is the home of Francis A. Hammond (it was later flooded down Cottonwood Wash), and at far right is the small home of Charles Goodman.

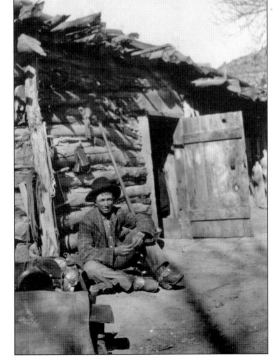

Cord Bowen is pictured here in about 1916, relaxing by his cabin. He married Gussie Honaker in 1916, and their daughter Hazel was born in this cabin in McElmo canyon. Hazel married local boy Lynn Lyman, and they lived in Blanding, Utah, where they reared their three children.

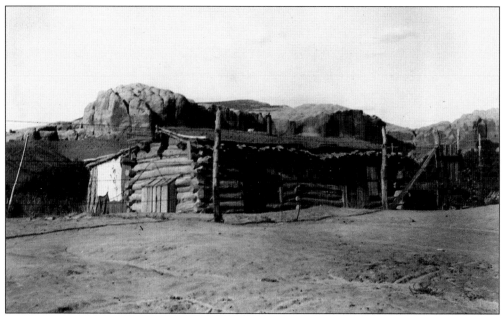

Eliza R. Redd's family lived in this Bluff cabin in 1907. Her husband, Lemuel Hardison Redd Jr., built a nicer home down the street to the west. They were in the original company of Hole-in-the-Rock pioneers. Eliza drove a covered wagon most of the way to Bluff. This hardworking couple had a large family. (Used by permission, Utah State Historical Society.)

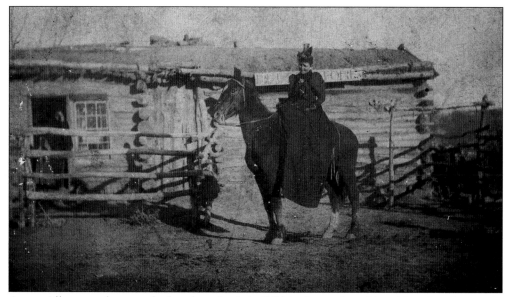

Agnes Allan was photographed on horseback in 1894 in front of a cabin with a sign that reads, "Bluff Fort." In 1883, families began to drag their cabins onto their town allotments.

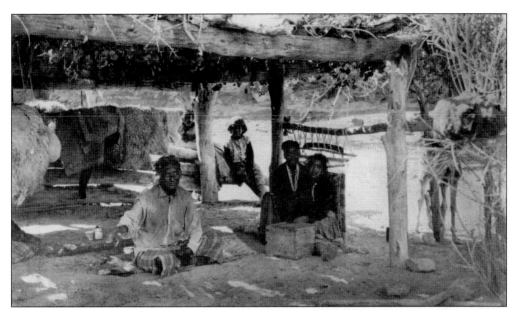

Jim Joe, a Navajo man, (far left) was a treasured friend of the early pioneers. Around 1911, his home was on the north side of the San Juan River, located near the Butler Wash. The majority of Navajo homes were on the south side. Joe negotiated difficult situations with the Navajos who stole cattle and horses from the settlers.

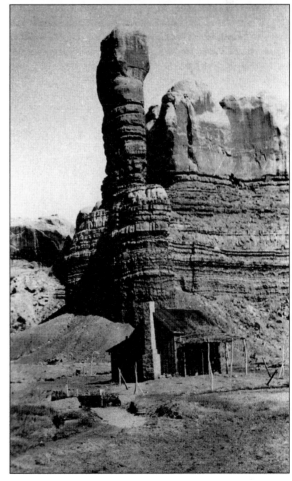

Joseph and Adalaid Hunt moved to Bluff from Kirtland, New Mexico, and bought this small lumber home in Bluff from Al Scorup in 1907. The couple attached a tent to accommodate their large family. Their children contributed to the communities of Blanding, Monticello, and Mexican Hat.

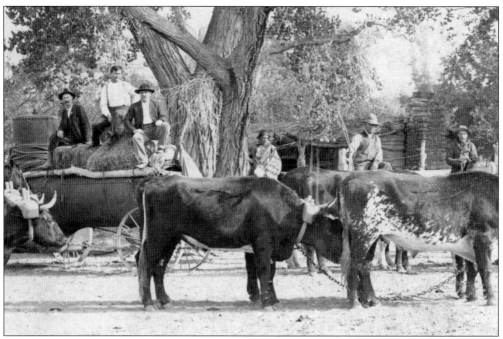

Photographed in 1894, this cabin was known as the House of Blue, because the inside was blue from tobacco smoke. It was built on the south side of the Bluff Fort. It is not known who built this cabin. It was a saloon and gambling business. Jim Douglas, Frank Hyde, and Thales Haskell are just left of the tree. The men in front of the building are unidentified.

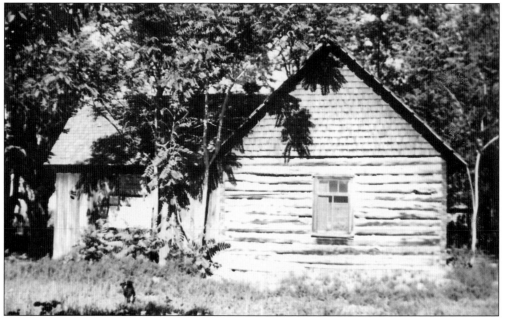

In 1896, Benjamin and his second wife, Sarah Perkins, lived in this Bluff cabin with their large family of girls and one son. They came through the Hole-in-the-Rock, where Benjamin played the major leadership role in dynamiting the rock and building a passageway for the wagon train. Benjamin was a musical Welshman. He fiddled, sang, and danced at most occasions.

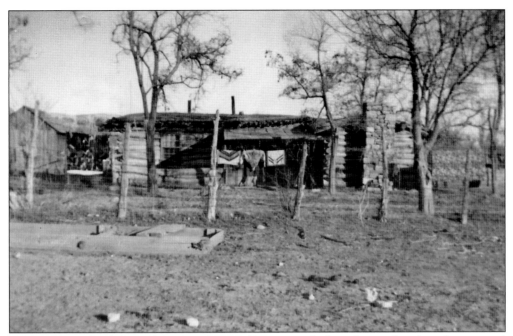

In 1910, this cabin belonged to Mary Ann and Benjamin Perkins. It was placed on the west end of Bluff. They lived in the home with their 10 children. Mary Ann and Ben were both born in Wales but met and married in Utah.

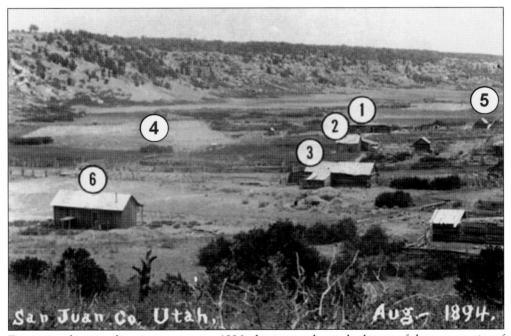

From an unknown observation point in 1896, this image shows the layout of the community of Verdure. The buildings are identified as: 1) an old log house (south room) built in 1887, 2) the George Adams log home, 3) Joe Nielson's community store, 4) the old Christian Lingo Christensen cabin, 5) the Willard Butt home, and 6) the Francis Nielson cabin.

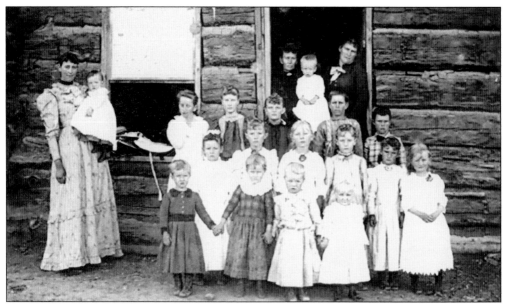

This 1894 photograph shows Edith Bayles holding Carl Butt on the far left. Primary schoolchildren are in front of a cabin in Verdure. Annie Christensen is standing in the doorway holding her son Wilford and daughter Alvida Butt. The children are identified in the archives.

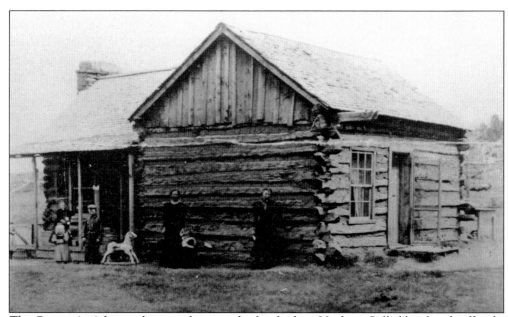

The George A. Adams cabin was the second cabin built in Verdure. Called by church officials, Adams established his home here in 1887. He served as the presiding elder for years. Pictured here from left to right are Hazel, Zola, Della, Bert, Evelyn, Von, and Cornelia.

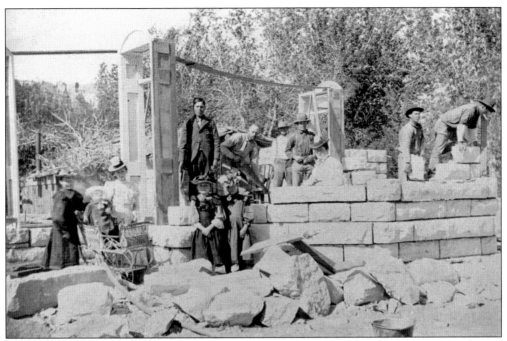

The Hanson Bayles family stands in front of their new rock home during its early stages of construction in 1900. The man in the suit is Hanson; at far left is his wife, Mary Ann. Other family members are posed in the photograph.

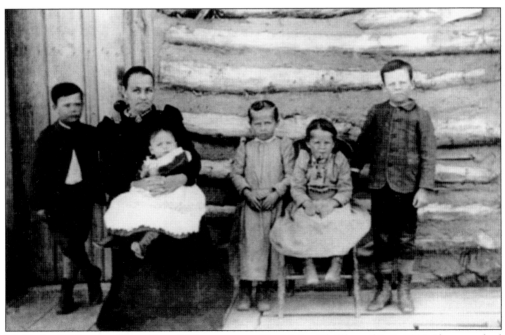

Ida Evelyn Nielson and five of her children are posed beside her Bluff log cabin in 1895. Photographed are, from left to right, Lyman, Ida (holding baby Alta), Ethel, Lydia (sitting on a chair), and Edd. Ida was the first schoolteacher in Bluff, and her husband, Joseph, was the merchant at the first private store in Bluff. He later moved the store to Verdure.

This early photograph of Monticello, Utah, shows the finished log church and school that sits in the middle of several log cabins. A few settlers moved from Bluff to this side of the Blue Mountain as early as 1888. The members were able to meet in this church as early as the following year.

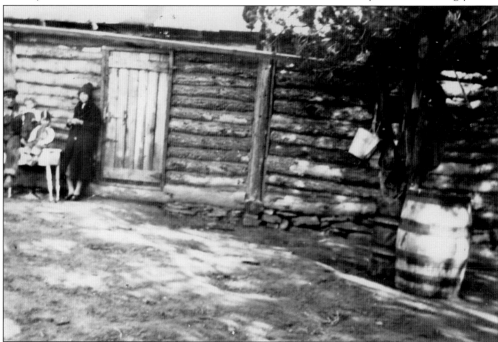

The young family in this photograph is not identified but from studying the attire of the young woman, experts most likely agree it was taken about 1929. However, local historians do know that it is a Bluff cabin. People were still living in two cabins when the author attended school in Bluff during the 1940s. The water bucket hanging above the water barrel was a necessary culinary tool found in most kitchens.

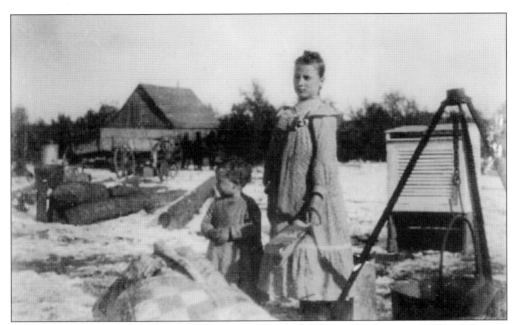

In the spring of 1902, Joseph "Jody" Lyman bought the LC Ranch at the top of White Mesa, in the hills above the Recapture Reservoir. Workers on the Johnson Creek ditch headquartered here. Pictured are his daughters Carlie and Angie. Lyman called the place Grayson. The town changed its name from Grayson to Blanding in 1915.

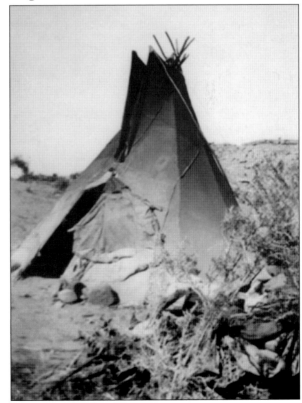

Max Fly constructed his tepee from animal hides during his stay on White Mesa in 1925. Nomadic Utes, the Native Americans of the Colorado and Utah intermountain region, lived on the mesas and close to the settlement of Bluff. The Utes and Piautes camped in the Bluff and Allan canyon areas in the wintertime and moved to the mountains in the summers.

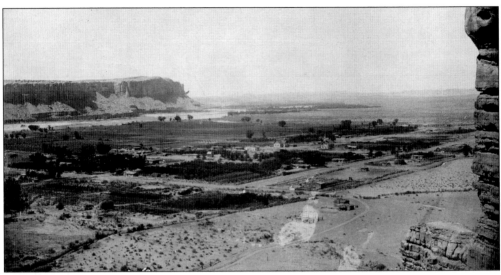

Charles Goodman's photograph, taken from a cliff in August 1894, shows the pioneers' progress 14 years after they elected to settle Bluff. The streets were clean of garbage and any unsightly disorder.

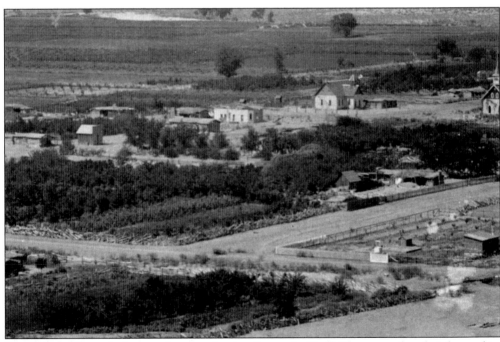

Photographed here is the completed rock schoolhouse in Bluff. The stone church is located to the right of the schoolhouse. Kumen Jones started the construction of his stone home around the time the schoolhouse was completed. Jones's home was the first permanent, private home built, shown here under construction. The home of Hanson Bayles was northeast of Jones's stone home. Joseph Barton's cabin was behind Bayles's home.

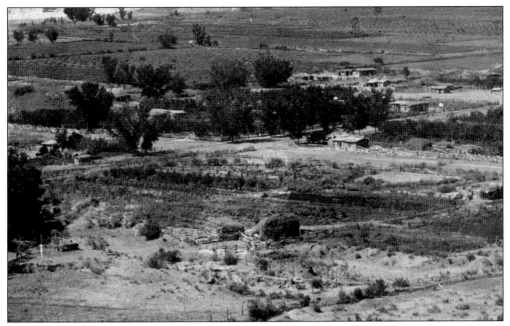

In this third view of the 1894 photograph, the pitched roof of Ben and Sarah Perkins' cabin on the far left is visible. In front of their cabin was the home of D. John Rogers. To the right of the Rogers' home was the cabin of William Adams, and in the center, by the small white square, was Monroe Redd's cabin until 1905. Gene and May Powell moved into this Redd cabin in 1909 and lived there until it burned.

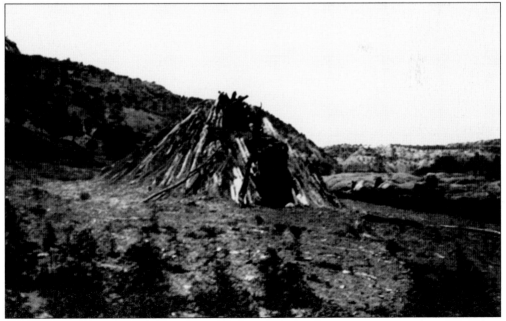

A forked-stick hogan, or a male hogan, was the typical home of the Navajo people. They lived directly across the river from Bluff. All healing ceremonies were held in a male hogan. Photographed in 1911, this male hogan was rarely seen even then because most had adapted to the female version, which is a rounded style.

The old Mendenhall cabin is located at the bottom of the Mendenhall trail, on the San Juan River 1,000 feet below. Mendenhall claims had names like 160 Booming Canon Placer Claim, Daylight Placer, Rose Bud Placer and Oil, Canon Placer Claim, and Juanita Placer. A hiking trail bearing his name is still maintained in 2000. (Photograph by Calvin McDonald.)

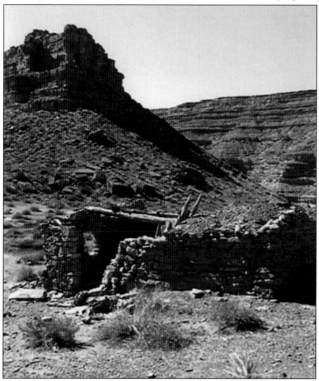

Mendenhall's cabin has survived the past 127 years and now, in 2008, serves as a lone testament to the gold rush. It has survived so long because it was built of canyon stone. Now hikers and other observers have the opportunity to see firsthand what it was like to live at the very bottom of the canyon. (BLM photograph.)

Two

Discovery of Gold and Oil in San Juan County

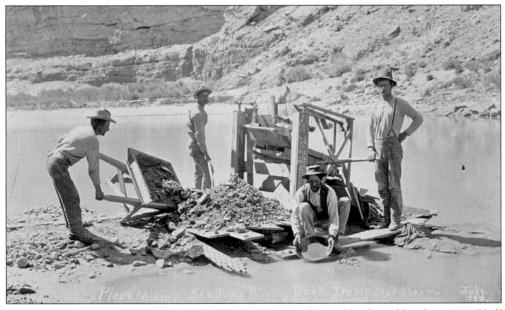

The struggling community members of Bluff were caught off guard by the gold rush in 1892. Bluff was the last civilized outpost, before the canyons and sand dunes went on for miles. Bluff welcomed the variety of business the gold rush brought. Bert Loper wrote that he walked 35 miles for 30 pounds of beans and had never imagined how heavy a sack of beans could be. By 1906, the gold fever had all but dwindled. But the oil drillers were just beginning to file in. Records show that in 1910 there were 15 oil companies with drilling operations, and in 1911, the number doubled in Harry H. Vinson's oil prospectus. Melvin Dempsey, a Cherokee Indian educated in geology, filed this Dempsey Gold claim, pictured somewhere on San Juan River in July 1894. Dempsey is holding the gold pan. They have their wheelbarrow, shovel, and gold pan to feed the dredge.

This photograph shows the Victoria gold camp in 1894, located somewhere near the San Juan River below Mexican Hat.

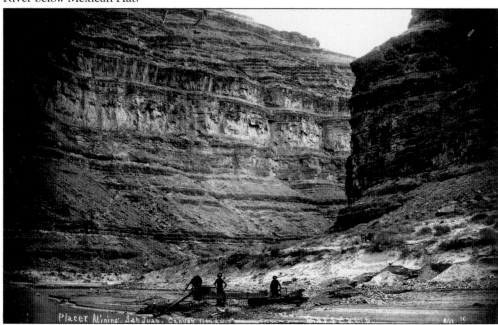

Placer Mining, San Juan, Canyon

The Ray families set up gold mining camps in the areas close to the Honaker and Mendenhall claims. Claims filed under the initials of E. J., C. A., E. C., and F. E. Ray had enough financial backing to maintain them. Their filings were to be known as some of the most productive workings. This photograph is labeled Ray's camp in 1894.

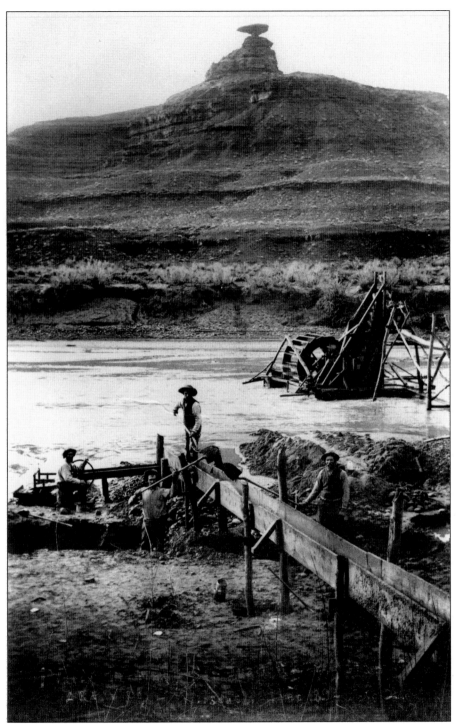

Adelbert Raplee brought equipment and money to the gold digging so he could advance his working operations in 1894. The name of this claim, which is working in full production, is not distinguished from the names of other filings. Its location is pinpointed by the Mexican Hat Rock formation in the background.

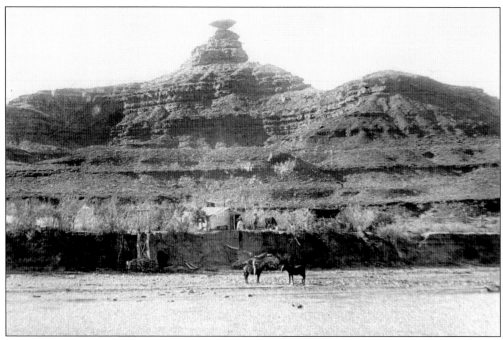

This is the Raplee camp pictured from a river angle in 1894. Raplee's wife, Hattie, and Charles Goodman are filed on the 160-acre claim called Log Cabin Oil and Placer Claim. It was located three miles upstream from the Honaker workings.

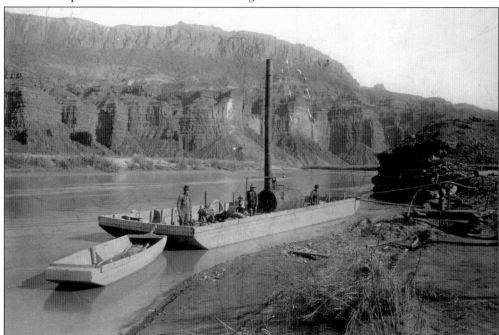

In 1894, Mendenhall used the San Juan River to transport his Atwood mining equipment. His early discovery filed on December 15, 1893, was known as the Round Knob Placer Claim. It was located two miles from the mouth of Gypsum Creek. Mendenhall returned to Durango, Colorado, that winter to pick up machinery.

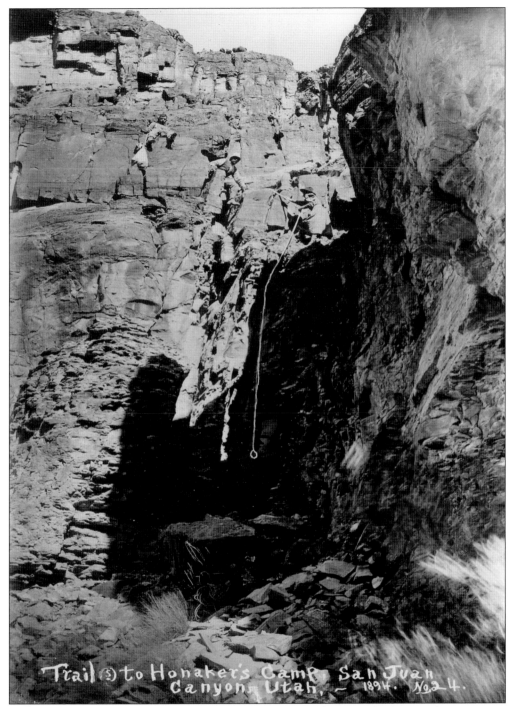

Ropes lowered mining supplies from ledge to ledge. The name of Charles Goodman appears on many of Honaker's claim papers. This 1894 photograph features Silas Honaker, A. C. "Gus" Honaker, and Dr. Snyder (the woman) descending to the mine below.

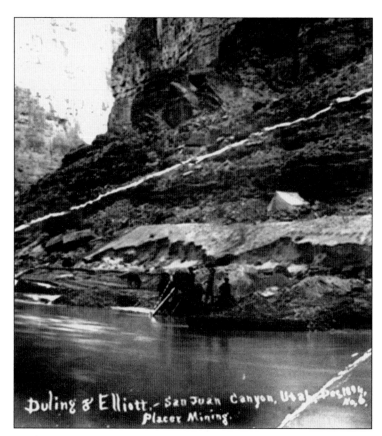

The Duling and Elliott placer mine in San Juan Canyon in December 1894 was around the corner from the Ray brothers' camp. This is an example of how close the mining claims were staked. The proximity made it easy for miners to visit each other's camps to discuss who made the big strike that day. (Utah State Historical Photograph.)

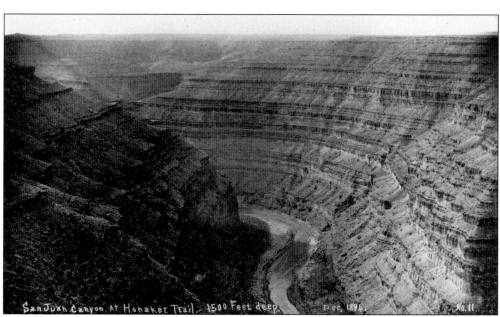

The Honaker trail can currently be viewed from the Goosenecks State Park overlook. The trail leads 1,500 feet down into San Juan Canyon. This photograph was taken in December 1894.

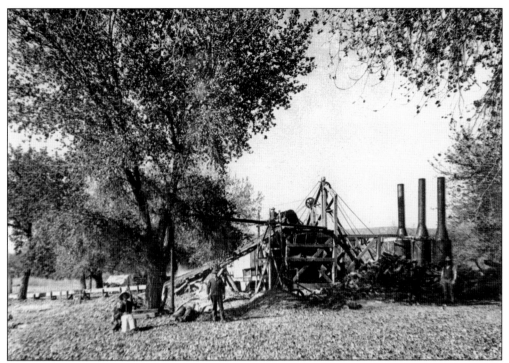

Portland Dredging Company is one gold operation shown to be operating right above the community of Bluff, about a mile. Claim workings were often on the lower part of the San Juan River, which was closer to the Mexican Hat vicinity. It appears to be one of the larger operations of 1894.

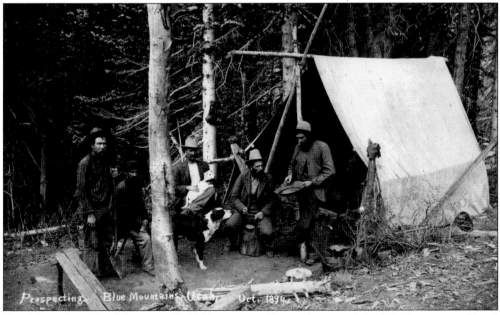

Posed here for a Blue Mountain Gold Prospecting Camp photograph in 1894 is a group of local prominent men. Pictured here are Bob Allan, unidentified, Jens Peter Nielson, Hans Joseph Nielson, and Charles Goodman (with the gold pan). Goodman also appears to have taken the photograph.

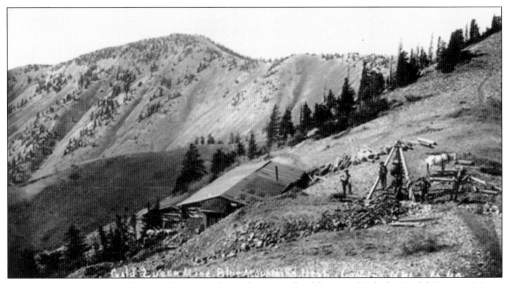

Southwest of Abajo Peak was discovered a rich vein of gold ore called the Gold Queen Mine, photographed in 1898. Stockholders owned the mine, but a mill owned by Ben Haywood was built below the mine with a tram to feed the ore from the mine to the mill. Rich as the vein was, it played out and Gold Queen Mine closed in 1903.

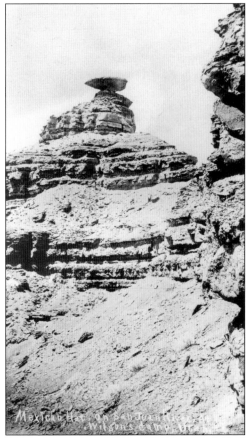

Wilson's camp is recorded as the gold venture in this photograph, showing that it is very close to the Raplee operations in 1894. This was typical of small miners trying to get as close as possible to the bigger operations. Mexican Hat Rock keeps its silent record of mining in the busiest of early times.

O. A. Smith and his gold rocker operation in San Juan Canyon were photographed in December 1894. Prospectors referred to him as "Crazy Smith." The reason for this name disappeared with the elusive gold he sought.

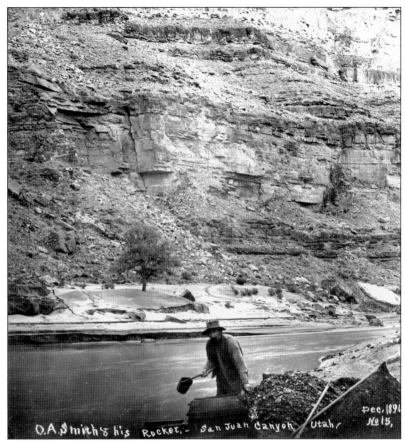

O.A. Smith's his Rocker, - San Juan Canyon, Utah. Dec. 1894 No 15,

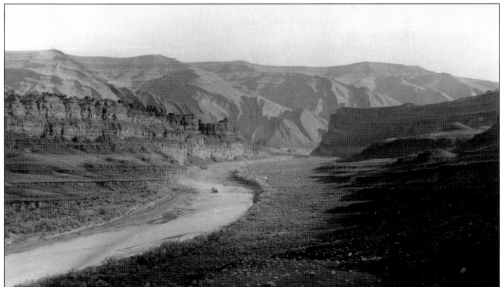

This distant view at Raplee's camp on the San Juan watercourse shows the area known as the San Juan Basin. The working dredge shown was the largest operation of its kind during 1894. The anticline in the background still bears the name Raplee Anticline.

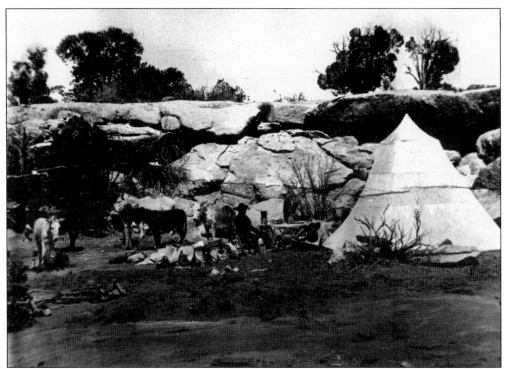

John Duckett's mining camp in White Canyon is pictured around 1894. This site netted the copper mines named by Duckett, Dolly Varden, and No Dream. His brother Joe Duckett recorded mountain sheep climbing nearby slickrock. John sold Dolly Varden in 1902 for $375 because the low-grade copper was contaminated by uranium. Uranium did not come into economic play until the 1950s, but fueled the boom that created millionaires.

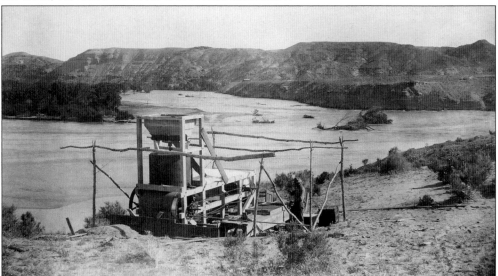

This distinctive placer mine from about 1894 appears to be a one-man operation of good working order, located upriver from Bluff in the area of Aneth. At least this miner was much closer to supplies and avoided the roughest canyons. As mining on the river waned, the mines on Blue Mountain and La Sal Mountain came alive.

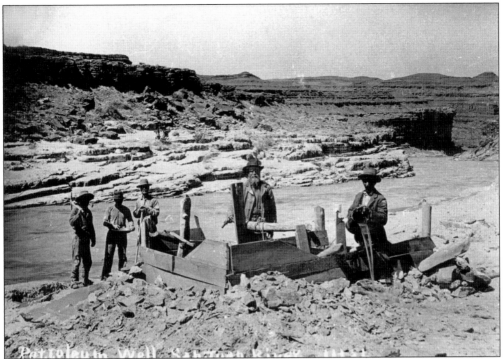

At Melvin Dempsey's first petroleum well, filed about 1898, Dempsey is shown here pouring a bucket of oil. His knowledge of geology brought him to San Juan, where he first sought gold; however, he quickly recognized oil seeping out of the shale in the cliffs into the river.

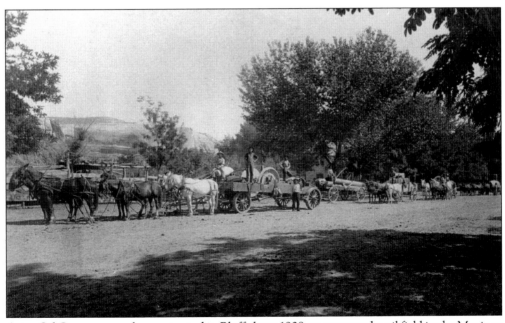

Aztec Oil Company employees stopped in Bluff about 1908, en route to the oil field in the Mexican Hat area, taking equipment. The service of many horses was needed for the sandy trails, running washes, and slickrock inclines ahead.

Five Swedes arrived from Minnesota in 1910 to diamond drill for oil. From left to right are Frank Johnson, Louie Petersen, John Johnson, and one unidentified man. John Johnson married Eva Hayes and spent the rest of his life in Bluff.

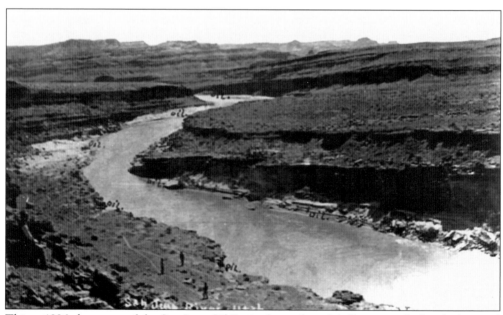

This *c.* 1896 photomap of the San Juan Oil Basin shows the oil drill sites marked with the word "oil." Years down the road, the image luckily tells what was considered the San Juan Oil Basin; otherwise, that knowledge might have been lost down the river. Problems dealing with drilling for oil in these areas 200 miles from a railroad were legion.

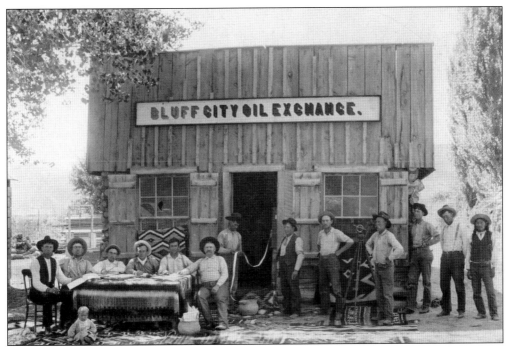

A. L. Raplee, Frank Hyde, and others organized the Bluff City Oil Exchange for local investors. Posed here in 1910 are, from left to right, Tom Humphrey, three unidentified, Frank Hyde, Jim Douglas, Dave Miller (holding ticker tape), Tom Tollman, two unidentified, Tom Jones, Al Scorup, and Posey. It is recorded that Jim Douglas made the largest known gold strike, taking out $1,500 in two hours.

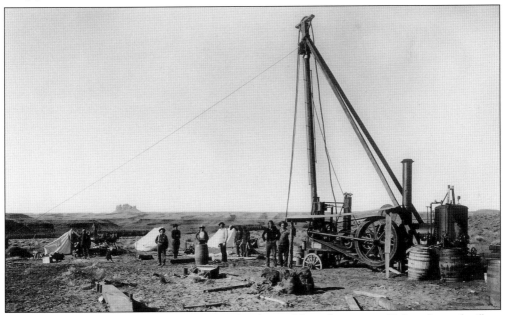

On March 4, 1908, Emery L. Goodrich struck oil at 225 feet, throwing it 70 feet above the floor of the derrick. Goodrich shouted, "We are rich, my boy! We are rich!" It was an area quote for many years. Any good fortune was often announced just the same way.

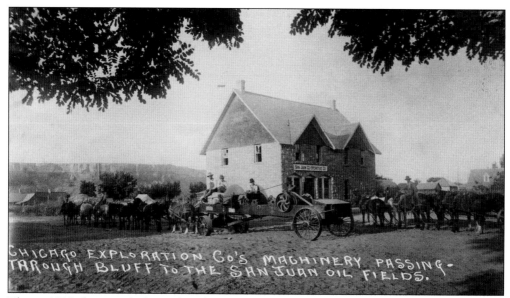

This *c.* 1909 photograph shows the Chicago Exploration Company wagons in front of the San Juan Co-op building. The area was so sparsely populated that laborers from other areas came to help drill.

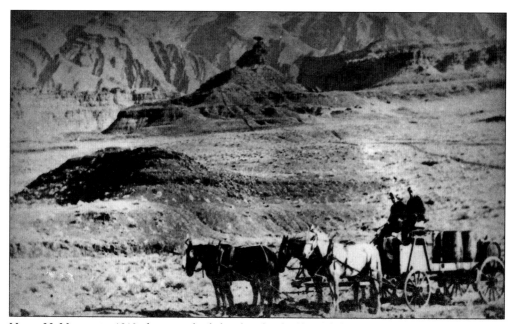

Harry H. Vinson in 1910 photographed this first load of his oil shipping out to market. It would be more than 200 miles to the closest railroad—mail service would not be in the area for years to come. The actual town of Mexican Hat was officially settled years later.

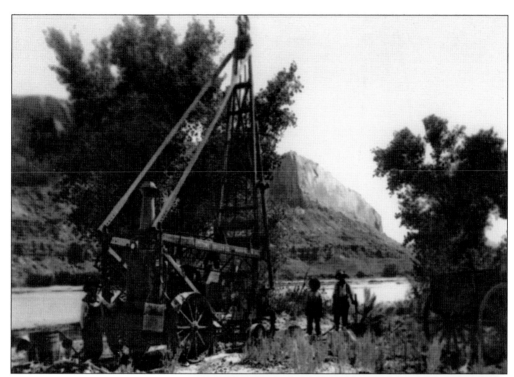

Taken around 1910, this photograph shows Keystone Drilling employees drilling a hole in the Bluff area, near Sand Island. Sand Island has a few sandy acres and trees. It was known as the river bottom. The oil drillers who came through Bluff were more anxious to make a few dollars so they were willing to drill water wells for the Bluff settlers.

Billy Nevills came to the country in 1917 searching for oil. He established this kerosene refinery near Mexican Hat and furnished products to the local population. George Wing leased the refinery in 1941, fired it up, and made products for a few more good years. Some of the oil wells there survive today as operating wells.

Connie Conway (on the fence) and George Wing are pictured at the North Dakota rig, near Mexican Hat, about 1945. Conway drilled for years after many other miners left for better fields. He married a local girl, Inez Nielson, and lived the rest of his life in San Juan County. The oil boom of the 1970s found the real oil ocean beneath, across the county in the Lisbon Valley and Aneth oil fields.

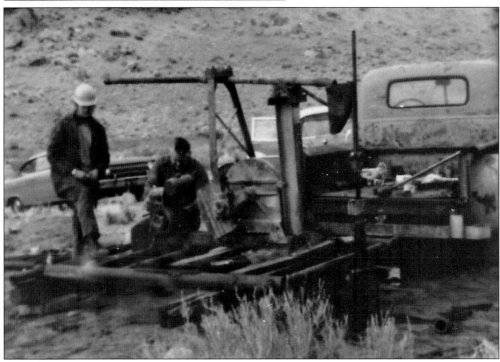

George Wing Jr. and George Wing Sr. put the Utah Southern on the pump in 1971 near Mexican Hat. It began pumping oil again, a first in 50 years. Oil in 1972 sold for $3.72 a barrel. The big oil fields were developed on the opposite side of San Juan County, near Aneth and Montezuma Creek.

Three

INDUSTRIES AND WATER

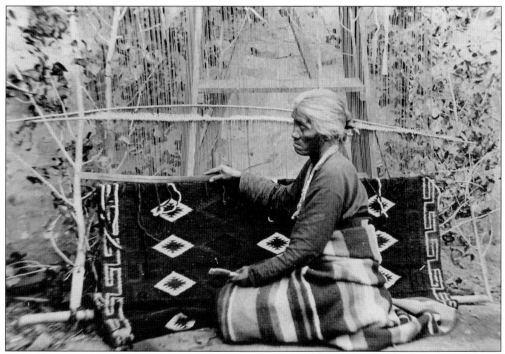

Early Bluff pioneers settled on the San Juan River and thought it would be plentiful water supply in the harsh environment, but they were wrong. On their first day in the settlement, a ditch committee was appointed to survey how to bring river water to their farms. Anglo settlers were amazed to see Navajo women taking wool from their sheep, dying it with natural dyes, and then weaving the wool into a rug. Rug dealers today would recognize this valuable old pattern The rug in the photograph is being woven in 1898.

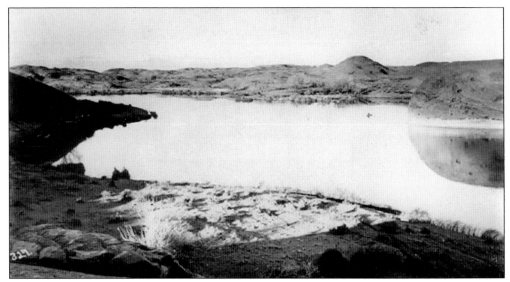

Lake Pagahrit ("standing water" in Ute) was where natural canyon runoff carrying logs, silt, and rocks had damned the Lake Canyon from wall to wall, forming the lake, shown here in 1894. It served the cattlemen for many years. A spring flood thundered down the canyon on November 1, 1915, and the lake was destroyed.

The first hand-dug well in the valley was inside the original fort to supply their daily needs. It is shown here beside the Joe Barton cabin, which is still on the fort site. Visitors can observe the rough-hewn board floors and log walls chinked with mud.

44

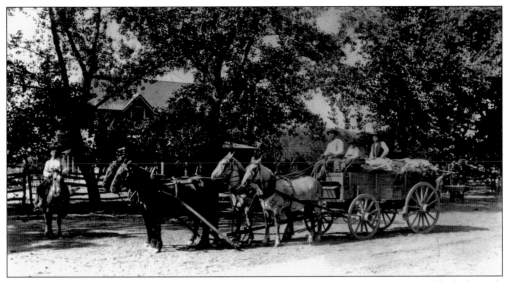

A Bluff freighter named Hancock was killed in the Cortez valley in 1907. Gene Powell, the branch president, drove the body to Bluff. The men from Bluff visited with Gene Powell, who was farming near Cortez, expressing their need for a freighter. Consequently, Gene and May Powell moved their family to Bluff in December 1908. He freighted for San Juan Co-op for about a year.

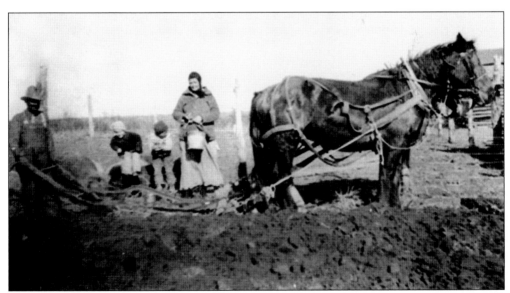

Wayne and Caroline Redd are busy preparing their gardens in 1884. Farming and ditch work consumed most of the men's waking hours, while the wives and children worked in the gardens and milked cows. In August, they watched in horror as a rainstorm caused a flood down the river that destroyed their ditch work.

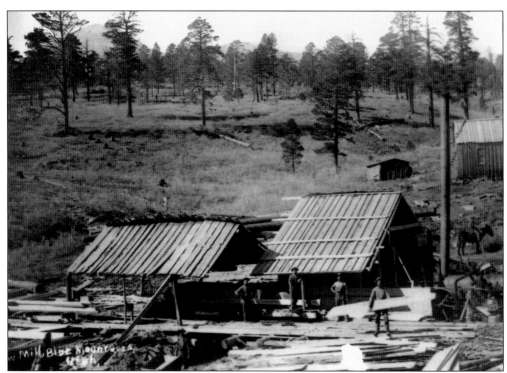

Willard and Parley Butt, along with C. L. Christensen and others, set up the first sawmill near Bulldog Canyon and built their cabins in Verdure, pictured here around 1896. The lumber was in high demand in the new communities of San Juan.

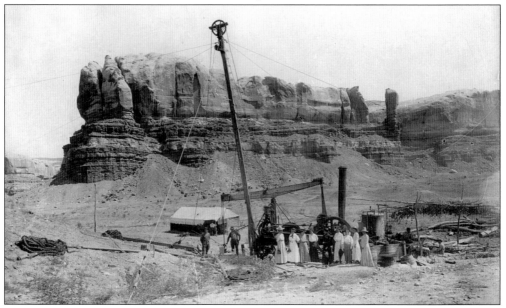

A group of local ladies are pictured at artesian well No. 2, drilled in 1908. Water from the well was eventually piped into their homes. Water was to be celebrated and was reached at an easy depth. The oil drillers who were moving drilling rigs into the area were happy to drill water wells while they waited to move down to oil field areas—it meant extra money for them.

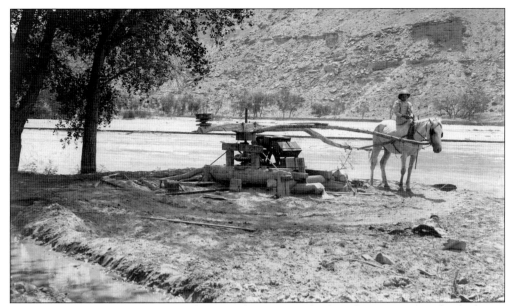

At Montezuma Creek, William Hyde built a large waterwheel to elevate water to the ditches at the rate of thousands of buckets of water an hour. Shown here in about 1890, Inez Thornell is pictured on the horse.

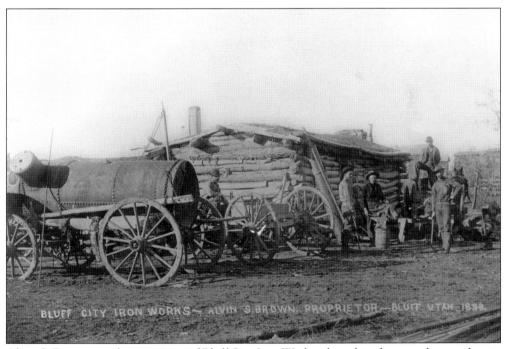

Alvin S. Brown was the proprietor of Bluff City Iron Works when this photograph was taken in 1898. The company was born of the needs of the gold-and-oil boom. The Bluff people also had many tasks for the blacksmith. The large water tank on the wagon often traveled over harsh terrain to serve its purpose.

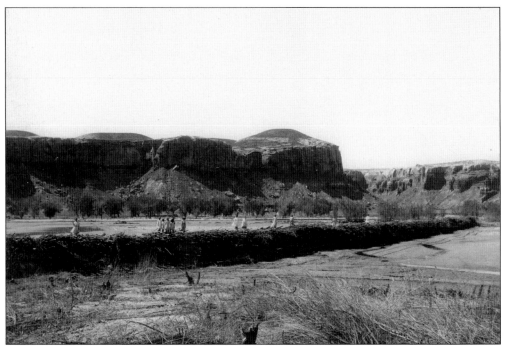

Following the big flood of 1884, the San Juan River changed its course and began to cut away the north banks from Montezuma Creek to well below Bluff, Utah. A 1,000-foot dam was constructed by the townspeople of Bluff to save the community from destruction, as it is shown here in 1894.

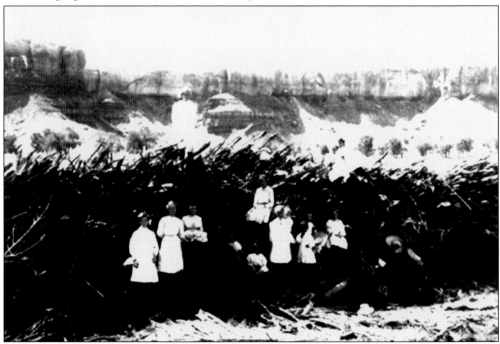

A close-up photograph shows children pictured with the materials that were actually a hardship to sacrifice to the community dam. Anything concerning water was an occasion to make a good photograph.

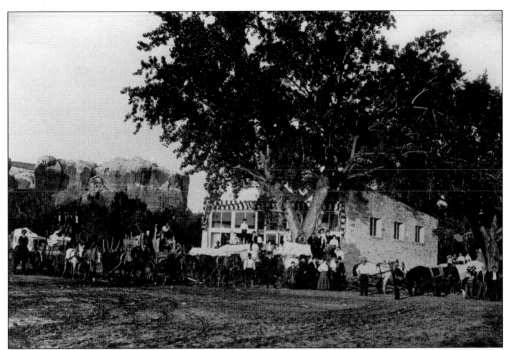

Frank Hyde Trading Post in Bluff is pictured in 1898 on a day the freight wagons arrived with fresh supplies. Gene Powell worked as a trader here for about a year, as he spoke fluent Navajo from his employment in Tuba City. As the boom days faded, Frank Hyde moved to Monticello and later to Salt Lake City. Claude Powell, Gene's son, used the building for a number of years as a trading post.

Quicksand was a common trial for county residents following the spring runoffs or in the mountain drainages. A man named Jock, photographed in 1914, struggled to get his horse out of the sand. Hopefully, the cameraman had a horse and could help.

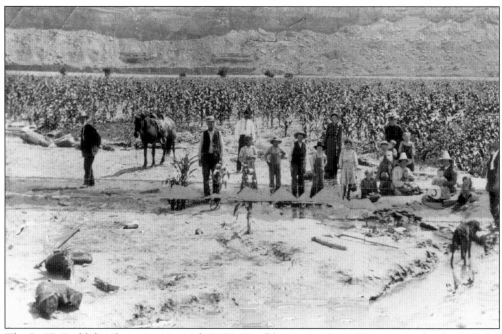

The L. H. Redd family is visiting with B. D. Harshberger in 1898. His crop at the farm in the river bottom southwest of Bluff is a result of where he drilled an artesian well. Kumen Jones is shown at the far left, and B. D. Harshberger is at center.

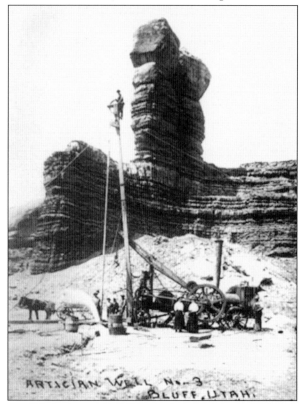

Here artesian well No. 3 is in the process of being drilled in 1910. Most county residents remember this well as a stopping place for all commuters. It was an open well that ran through ditches to the community but had a small pool here. The Navajos and Anglos stopped to fill containers.

Dan Hayes prepares for the day's work on the range by filling his large water bag, which was made of canvas and kept the water cool for the long day. No one went very far in 1926 without a water bag.

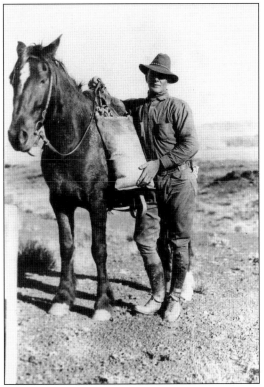

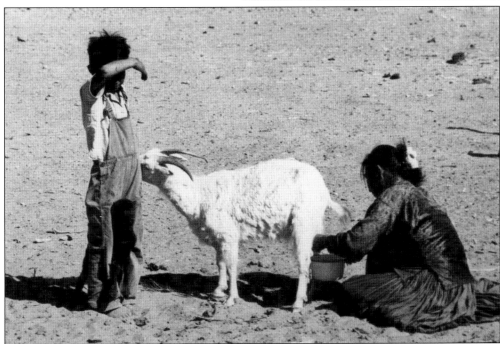

Claude Benally holds the goat for his mother, Sadie John Benally, while she milks it in 1940. It was a daily source of their family's nourishment. This Navajo family lived east of the community of Bluff, Utah, a few miles upriver.

John and Louisa Wetherill built the Wetherill Trading Post about 1901 at Oljato, providing services to the Navajo people. They moved their business to Kayenta, Arizona, in 1912. This photograph was taken after it was abandoned, when the trading post's only customer was the drifting wind.

Coyote Creek flows freely from the high La Sal Mountains and is fed by a good spring year round. It has provided water for more than a century to cattle and people in the northern end of San Juan County. Photographed here in 1998, it is still a main source of water.

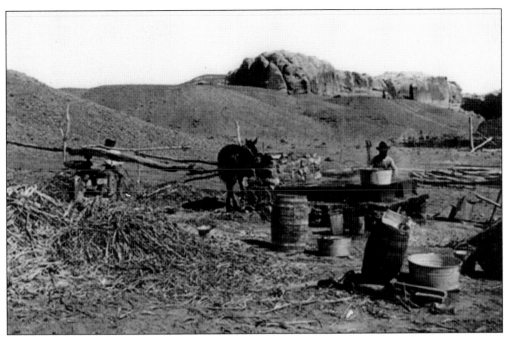

A molasses mill built southwest of Bluff's Cemetery Hill about 1894 served the community, as they were finally beginning to pull in some crops even though ditch work still took a great deal of their time. The first year, 1880, it was recorded that all their ditch work washed away and the year's work was a failure.

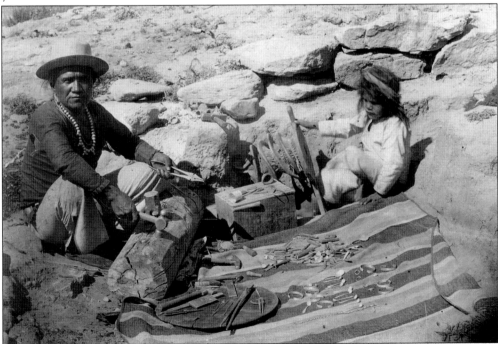

Atcitty and his son have all the tools of his silver workings displayed for the photographer, Charles Goodman, in 1898. Atcitty's work was sought after by his Navajo tribe members. The Anglo settlers in Bluff began to admire his artistic creations.

In 1926, June Powell, who operated a trading post in Bluff, utilized this abandoned rock building at Mexican Hat. He stocked it with goods and hired Ray Hunt as the trader. Hunt bought out the stock later that year, and he operated it as the Hunt Trading Post. Jim Hunt, Ray's brother, came home from the military in 1946 and bought it.

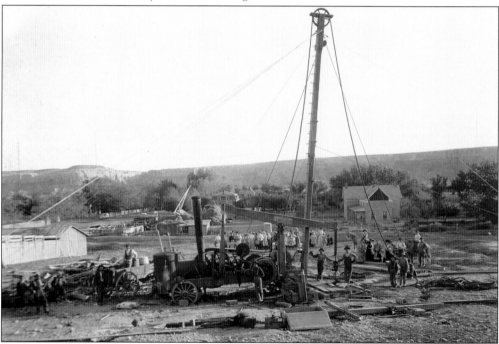

People gathered for the dedication of artesian well No. 1 in 1908. Water was a commodity that was always in high demand in the desert environment. Hans Joseph Nielson's home is in the background.

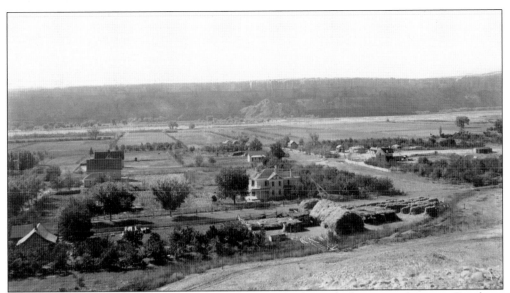

This view of the west side of Bluff in 1910, looking south, shows the bounteous hay crop. Residents had completed some rock homes by this period. In the center is Leland H. Redd's large home, and on the right is the home of Hyrum Perkins. The left side shows the small Relief Society building, the church next to it, and the schoolhouse.

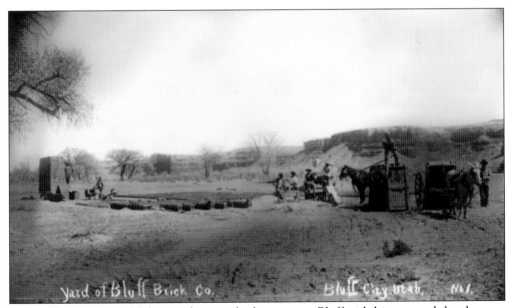

Yard of Bluff Brick Co. Bluff City, Utah. No 1.

One gold miner, a Mr. Mulenix, who went broke, came to Bluff with his son, and they became brick makers about 1895. They organized a fine business, and many of the local houses were built from the efforts of this new industry. At least they could make the San Juan River productive.

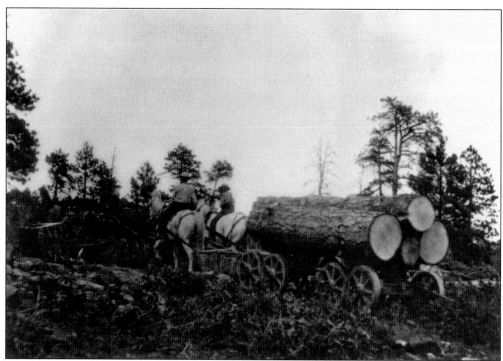

The Blanding Co-op harvested this load of logs on Blue Mountain in 1911. Demand for lumber was steadily increasing with new county growth. It was a hard-earned commodity.

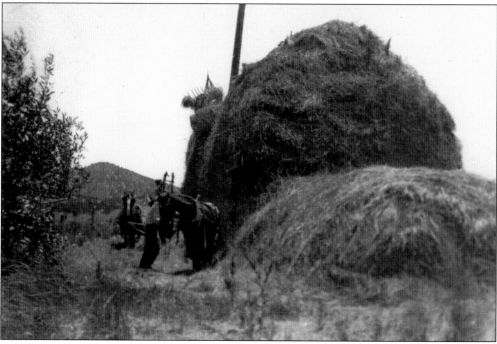

These horses and haystacks are located at the Indian Creek Ranch in 1918, operated by the Scorup outfit. Wonderful hay crops are still grown in this area and watered by modern sprinkling systems for the Dugout Ranch Conservatory, which will always be an operating cattle ranch.

Blanding's first source of water was the spring in Westwater. Everyone had to carry water from the Westwater canyon, which was supplemented by rainwater caught in cisterns. Navajos, Utes, and Anglos were all dependent on the spring that is shown in this c. 1918 photograph. The children's first task of the day was to run to Westwater with the water bucket.

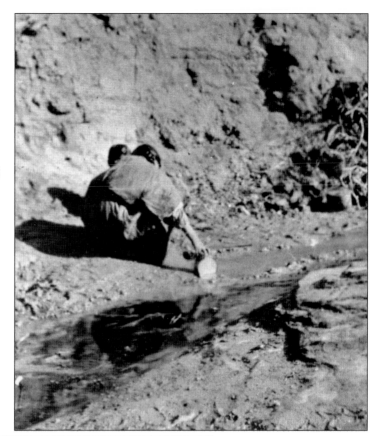

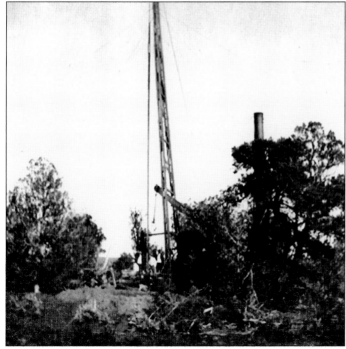

The first water well drilled in Grayson (later Blanding) was across the street from the old Seth Shumway home in the vicinity of 312 North and 400 West Streets in 1912. A wooden pipe system was constructed. It carried the water to the property owners in the small community.

F. I. Jones is standing in his crop of wheat he grew in Monticello, Utah. Water was a continuous struggle for the community of Monticello. They fought, at times, with the big cattle companies for water rights.

George Turner waters his garden in John's Canyon. Notice that the water comes from the water barrel hauled from the San Juan River for this purpose. Considering the arid conditions in the area of John's Canyon, George was a very optimistic soul indeed in 1925.

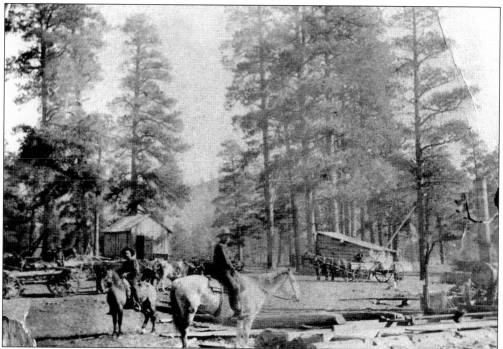

Daniel S. McCollum, pictured on the horse in front, operated the first sawmill on La Sal Mountain, shown here about 1890. He sawed timber in the La Sal Pass, Old La Sal, Buckeye, and Pine Flat areas. Most of the ranch buildings, mine timbers, and farm buildings were purchased from him in the earliest days of northern San Juan County.

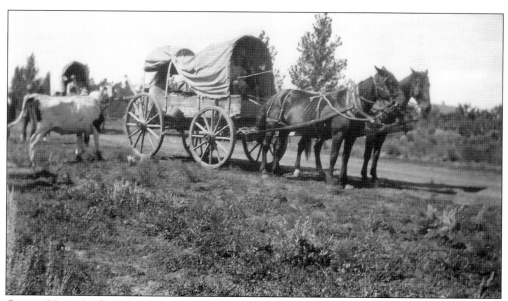

George Hurst Jr. drove a team and wagon from Dublan, Mexico, to Grayson in 1911. Poncho Villa was driving the Mormons out of Mexico and confiscating their property. George was 15. His father operated a blacksmith shop in Grayson for years. A large influx of people from Mexico came to Grayson.

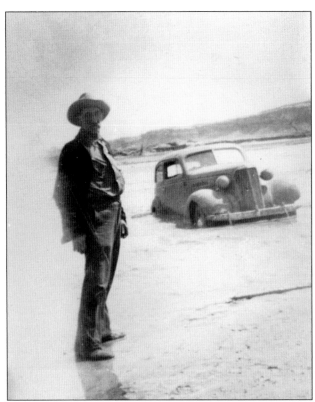

Bob Wise, a Bluff local, surveyed the car that belonged to George Wing Sr. He found it stranded in the flooded Cottonwood Wash in 1941.

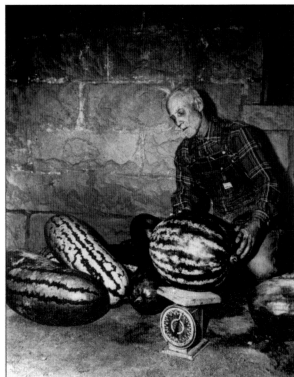

Lum Gaines, a well-known farmer in Bluff, spent many years plowing and cleaning ditches with a team of horses. He routinely worked days and nights. This 1942 photograph displays his famous, huge watermelons.

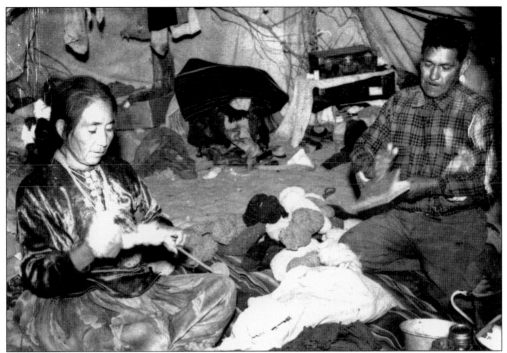

Sadie John and Randolph Benally are pictured in 1949 in their hogan, which was about three miles east from Bluff and up the San Juan River. They are preparing wool by carding and spinning it into yarn for Sadie to weave into a Navajo rug. She would then sell it to the Bluff traders to buy food and supplies for her family.

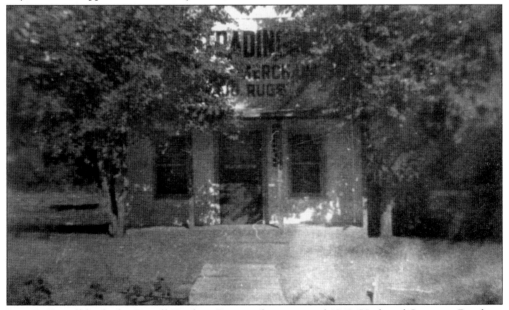

June L. Powell built the Powell Trading Post in the winter of 1943. He hired Simpson Brothers to be the carpenters. He stocked merchandise to trade to the Navajo and Utes for pawn, sheep, and wool, and exported Navajo rugs to Gallup to sell. The trading post served the people in Bluff until Powell's retirement in 1957. Powell is the father of the author.

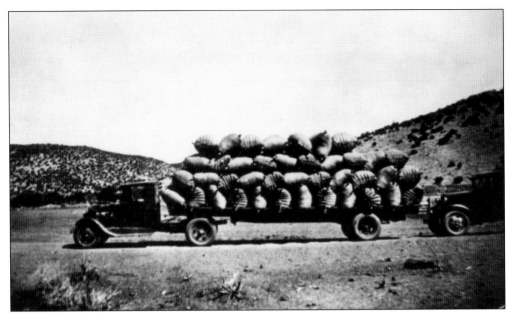

Here is Joseph Barton's truck loaded with sacks of wool and headed to the railway at Dolores or Durango around 1926. Wool was one of first exports and provided a cash profit for Navajos to sell to the trading posts. The sheep ranchers in the area exported wool. They often bought the wool from the trading posts.

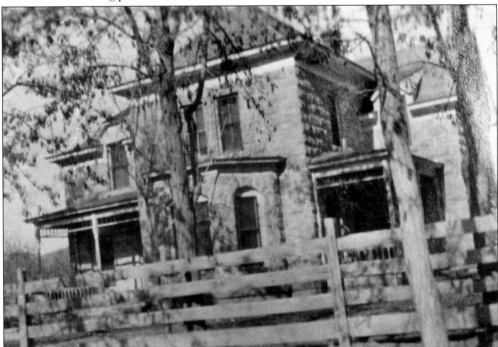

This house was built around 1895 for Fred and Agnes Adams. Fred died unexpectedly of typhoid fever at his placer gold claim called Cable Camp on the San Juan River. Agnes's second husband also died unexpectedly. Agnes turned her large home into a boardinghouse and hotel called the Adams Hotel. It is still standing in Bluff and is on the National Register of Historic Places.

Four

SAN JUAN CO-OP AND RANCHES

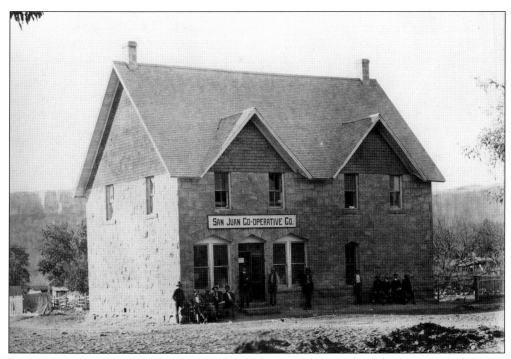

The San Juan Co-op was operating by 1882 to serve the freighting of supplies into the community. In 1884 and 1885, New Mexico sheep were trailed into the area by the Daniel-McAllister outfit. They moved onto the range, which was needed by the Bluff settlers. On January 16, 1886, Francis A. Hammond organized a group of local investors called the Bluff Pool. They bought the sheep herd with financing from Durango, Colorado. This stone building was finished in 1908, providing more services for the San Juan Co-op customers. Mary Jones was the first clerk here. Kumen Jones was the general manager for years. The author's grandfather, R. E. "Gene" Powell was the trader to the Navajos here from about 1910 until 1920. John L. Hunt bought the store in 1920 and operated it until it burned down in 1925.

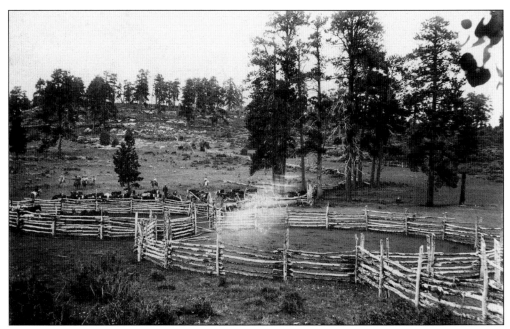

Photographed in 1898, F. Jacob Adams's cattle are shown in the corrals on Elk Mountain at Twin Springs. Jacob Adams drowned on October 1940 while swimming his horse, Blue, across the flooded White Canyon.

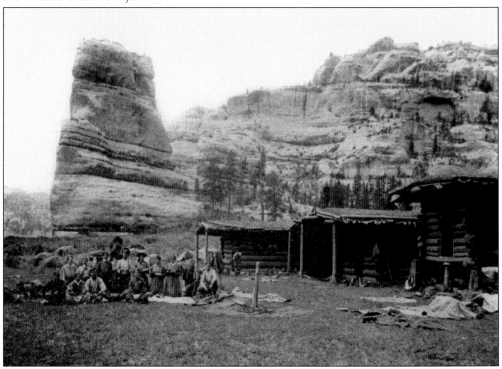

Bluff residents are pictured here in 1908 after traveling to Elk Mountain for a summer outing. Cattle allotments on the mountains were used as summer range. The ranch cabin belonged to L. H. Redd in Dark Canyon.

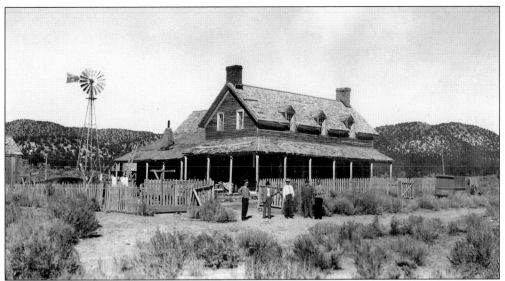

Clarence and his brother, Buck Lee, built Lee's Ranch in the Valley of the Gods, a 12-hour horse ride from Bluff, in 1933. Before building the ranch, they lived on the Piaute Strip on the Navajo reservation. They were ordered to move, so they relocated to the Valley of the Gods.

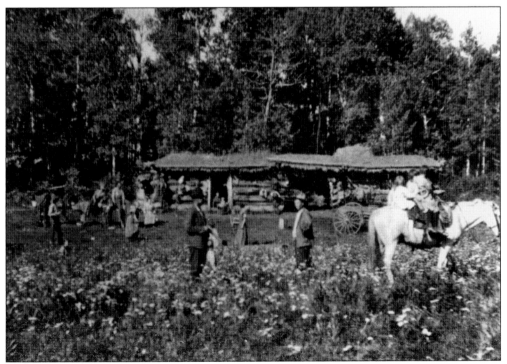

Some families passed the long summer days by going to the Wooden Shoe cattle headquarters. This photograph was taken in 1913. J. Albert Scorup, a local cattleman, and J. W. Humphrey, the forest service supervisor, are standing in front.

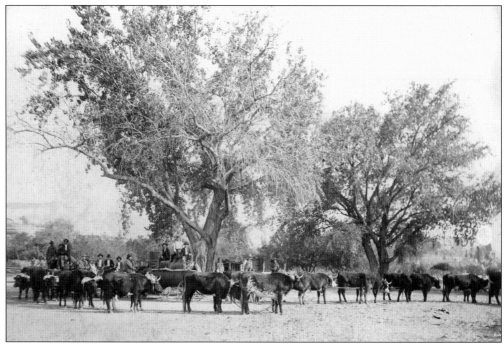

In 1887, employees of the Galigher Texas Cattle Company drove 3,000 head of cattle through the streets of Bluff, Utah, on out to the range west. The cattle drive was three miles long. They moved onto the Comb Ridge winter ranges. The abandoned Barton Trading Post buildings served as their camp.

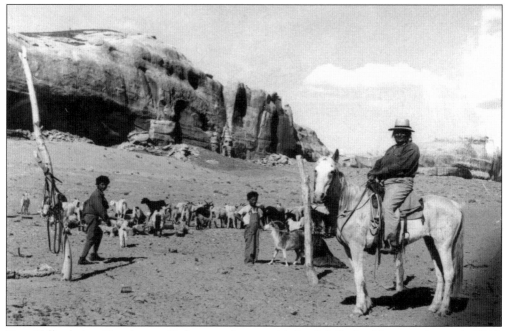

Fatty Yellowhair, a Navajo grandfather, watches over his family's flock of sheep and goats in 1944, while Claude Benally, center, and Frank Benally, left, follow instructions about moving the animals to graze. They had to take them home to the corrals at night to avoid the preying coyotes.

The location of the cabins at the F. Jacob Adams's cattle ranch on Elk Mountain in 1894 was where the Galigher Texas Cattle Company was sold to Bishop Jens Nielson (agent) and added to the Bluff Pool in November 1888. F. B. Hammond became the foreman for the Bluff Pool. The organization borrowed enough money for the transaction in Durango, Colorado.

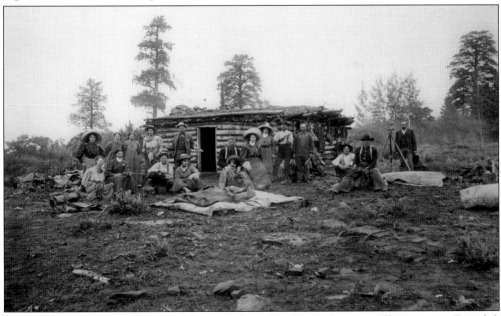

Featured here is a group of young adults at the Lone Star Cattle Camp on Elk Mountain. From left to right in August 1907 are (sitting) Alice Wood (or Dola) Adams from Parowan, Kisten Adams Perkins, Charlie Redd, Edith Redd, Thomas Humphrey, Sarah Perkins Barton, Lyman Nielson, and Ernest Adams; (standing) Carlie Redd Shirtliff, Livina Michelson Redd, Elsie Butt, Alta Nielson Cox, Franklin J. Adams, Ethel Nielson, Hardy Redd, Henry Pherson, and Peter Allan.

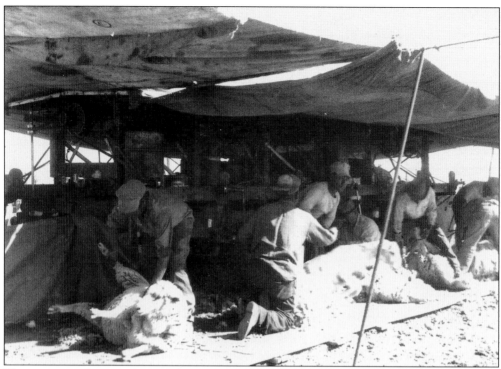

These men are shearing sheep under a tarpaulin roof for protection from the heat. It is the fall of 1940, and they are shearing in the pens at the bottom of White Mesa hill for the Adams brothers, Joe, Lloyd, and Melvin.

Dan Lehi is on Elk Mountain for fall roundup on the Ute Mountain Tribe range. This photograph was taken about 1949. Carl and Kloyd Perkins sold their Elk Mountain range to the Ute Mountain tribe, which increased the tribes' grazing permits and sizes of their herds considerably.

Lyman "Bogh" Bayles has his pack animals and equipment loaded for the day's ride on the range. Bayles and his brother Grant's ranch covered miles of Allen Canyon and the west side of the Blue Mountain. Their cabins are still standing.

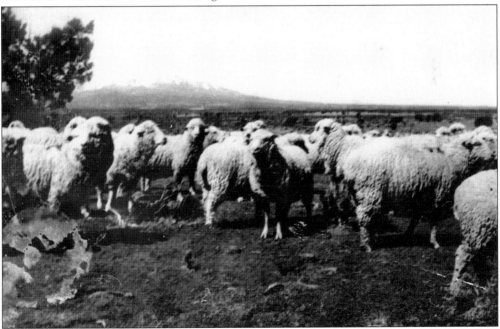

Reed Bayles's sheep are grazing in view of Blue Mountain around 1935. Cattle and sheep have sustained the economy of San Juan for more than 120 years. Bayles operated both sheep and cattle, which was normal for large companies.

J. M. Cunningham and P. B. Carpenter, along with Fred Prewer, purchased the Pittsburgh Cattle Company in 1895. La Sal Mountain is shown on the horizon behind ranch hands heading for work. San Juan and Grand stockmen purchased the outfit in 1914. Charley Redd became the manager in 1915, and he later became the owner.

Fred Prewer went to work as a young man for the Pittsburgh Cattle Company. He established this ranch about 1894. He also established schools and developed services to improve the La Sal area.

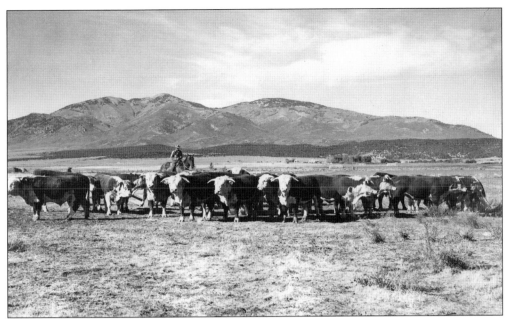

George M. White, foreman for Redd Ranches, drove a select herd of bulls, photographed here around 1939. The La Sal Mountain furnishes plenty of summer range yearly to the longest continuous operating ranch in the northern area.

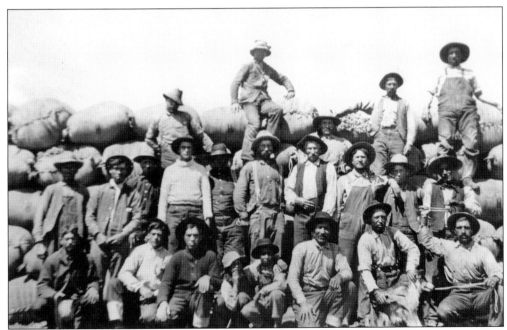

Mexican shearing crews finished their work with Redd Ranches sheep in the spring of 1939. F. R. Lopez, who supervised the shearing and tromped the wool in each bag, is on the far right in the front row.

Joe Smith is on his horse Rex with Corry Perkins on Cap riding on the Perkins family's summer range near Kigalia. The Perkins summer range was around the Milkranch Point, Hammond Canyon, and Butts Point areas. Corry's son, Richard, has stayed in the cattle profession, following his father's sudden death.

Brig Stevens heads to the range for a day's work, about 1945. Stevens's family members established a ranch in Mormon Pasture called, at one time, Stevens Canyon on Elk Mountain. They were called by Stake church president Francis Hammond to ranch there and prevent big cattle companies from moving on the ranges.

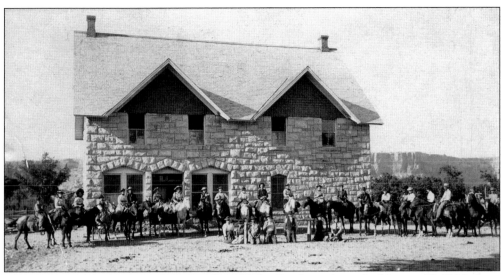

These men and women are meeting in front of the San Juan Co-op building in Bluff, Utah, in 1905. They plan to ride out to visit Elk Mountain just for a summer excursion. A few of the riders are identified in historical archives.

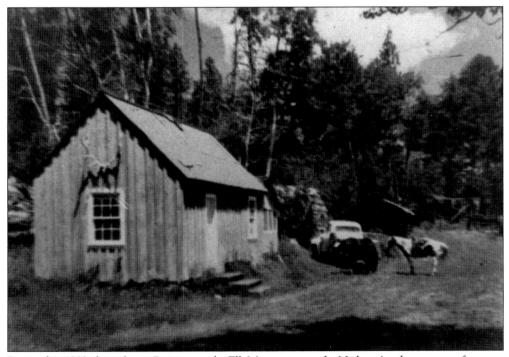

Pictured in 1929, this cabin at Peavine on the Elk Mountain was the Nielsons' early cow camp for many years. It was called Peavine because of the wild sweet peas that grew and blossomed there. Preston Nielson's cattle enterprise was the last of the Nielson ranchers to have headquarters here.

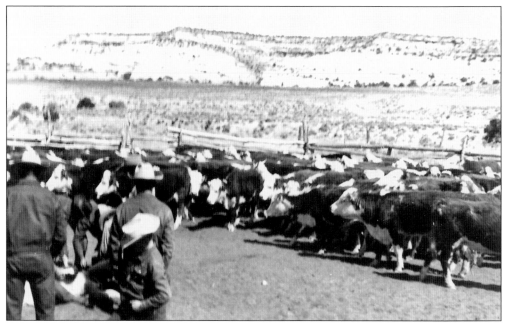

An SS Cattle Company (Scorup and Somerville) roundup is in progress at the Seeps around 1929. A roundup always involves a number of tasks to get steers ready for shipping: branding calves, counting herds, and perhaps dividing them into different groups for different ranges.

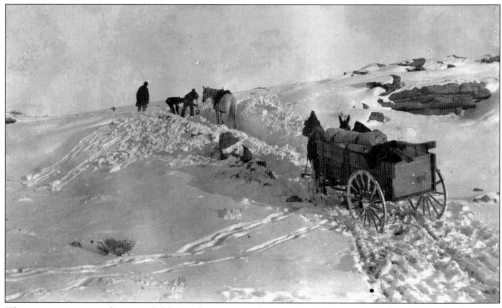

There was no snowplow available in this county for another 80 years. The best help for this was an extra hand and an extra shovel. A. C. Honaker looks on as Posey, with Silas Honaker, clears a path for the freight wagon of supplies going into his store near Mexican Hat in 1885.

Five

FIRST CHURCHES, CHURCH GROUPS, AND SERVICES

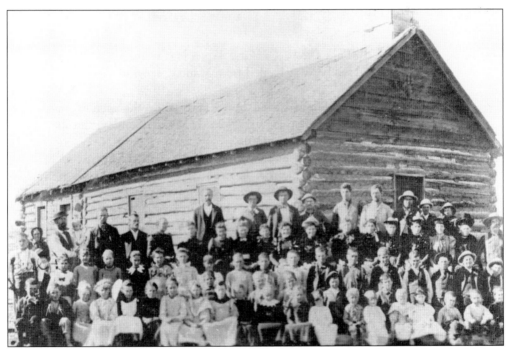

The Church of Jesus Christ of Latter-day Saints has always encouraged its people to build their churches for adequate places to worship. Other faiths, as they moved into the area, have consistently followed suit for their congregations. Medical services, for many years, were also centered on the faith and talents of the faithful pioneer citizens. They were always encouraged and blessed by their church leaders. This log church/schoolhouse was built in Monticello, Utah, in 1888 and photographed here with local Sunday school members. A replica of the old church was rebuilt for the 1996 centennial of Utah statehood. F. I. Jones, one of the earliest settlers, donated the original land. The church stood about where the San Juan Pharmacy is today. The replica stands slightly south of it in Pioneer Park on Main Street.

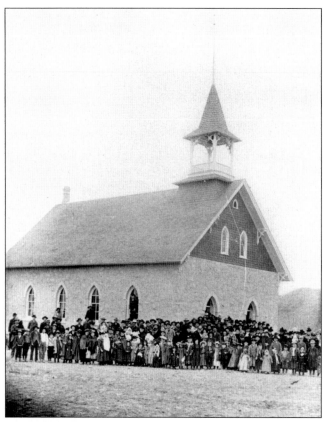

The Bluff members of the Church of Jesus Christ of Latter-day Saints are gathered here to dedicate their church, which was finished the year before but dedicated on February 23, 1895. It was their church leaders who called them on the mission to travel to San Juan. The first permanent building that they finished was their church. It is no longer standing.

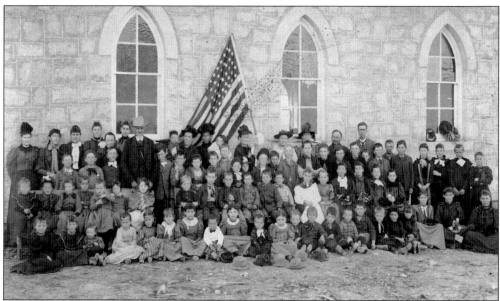

Bishop Jens Nielson celebrated his 74th birthday with the primary children in Bluff, Utah. His feet were frozen on his trip across the plains of the Midwest to Utah in earlier years; therefore, he was given the name "Crippled Feet" by the Bluff Navajos. Josephine "Jody" Woods, as primary president, is holding the flag.

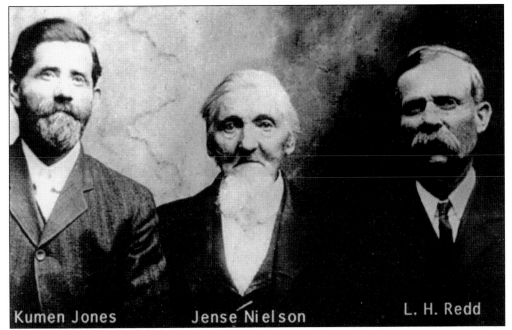

Kumen Jones Jense Nielson L. H. Redd

The church placed Bishop Jens Nielson (center) with Kumen Jones (left) and L. H. Redd in church leadership positions. Bishop Jens Nielson served as Bluff's bishop from September 1880 until he died in 1906. He was a Danish man with a heavy accent and was noted in Bluff for his kind leadership and his "sticketytoit" attitude.

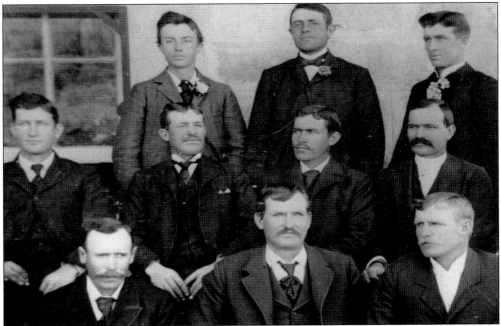

This photograph features the elders who left for the mission field in 1899. From left to right are (first row) Peter Allan, Jens P. Nielson, and Frances Nielson; (second row) Henry Woods, Joseph Hammond, Willis Rogers, and Wayne Redd; (third row) Albert R. Lyman, George Perkins, and Arthur Woods.

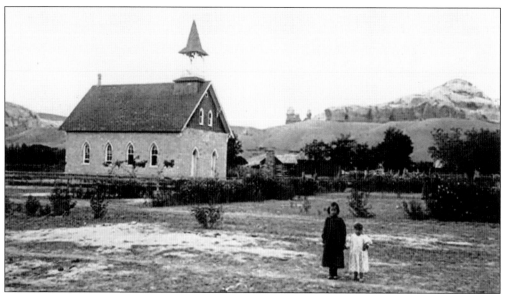

Two children stand by the Bluff church around 1896. The bell tower served as the community's clock and was rung to announce church meetings, fire alerts, and Native American attacks. The L. H. Redd cabin is just to the right of the church, and the cliffs are in the background.

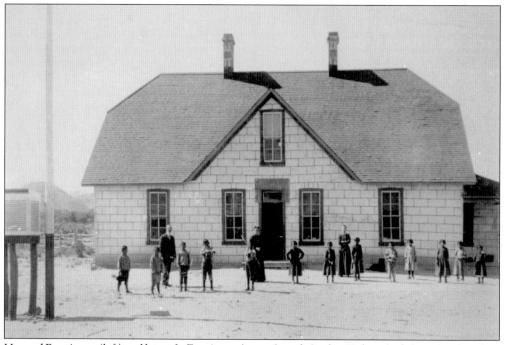

Howard Ray Antes (left) and his wife, Eva Antes (center), with Sophia Hubert (right), a schoolteacher, are the adults in this photograph of the Navajo Faith Mission, which was established in Aneth, Utah, just upriver from the community of Bluff. Howard Ray Antes was a controversial Methodist minister who established his church in 1895 and dispensed charitable food and clothing items that were donated from eastern sources and freighted in by Navajos. Aneth was called Riverview at this time.

Sagebrush shows beside the tent church/school in this photograph taken on June 13, 1907. Not enough children lived here the first two years, so families with children went back to Bluff during the winters. The building stood on the town square and was called Grayson School. Lucretia Lyman Ranney was the first schoolmarm in Grayson.

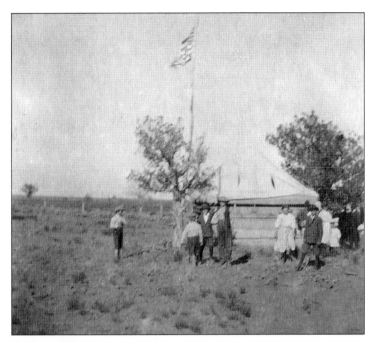

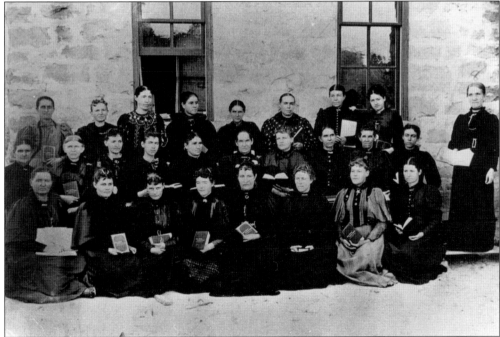

Hannah Sorenson (far right) taught home nursing classes in Bluff in 1896. Also pictured are (first row) Mary Nielson Jones, Harriet Barton Hammond, Agnes Allan Pherson, Jenny Decker Wood, Ann Bayles, Annie Decker Wood, Caroline Hammond, and Sarah Perkins; (second row) Josephine Wood, Cornelia Mortensen, Annette Nielson Johnson, Celestia Stevens Hancock, Marion Bronson, Lucinda A. Redd, Caroline Nielson Redd, Corry Perkins, Celestia Hammond, and Lettie Stevens Jensen; (third row) Lydia Lyman Jones, Evelyn Adams, Emma Scorup, Eliza A. Redd, Annie M. Decker, M. M. Halls (from Mancos), Adelia Lyman, and Evelyn Lyman Bayles.

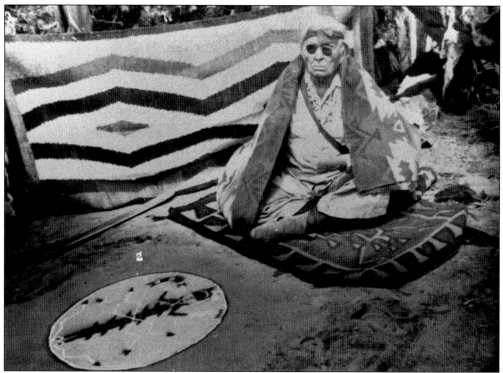

A blind Navajo medicine man finished his sand painting preparations to continue the healing ceremony for his patient about 1896. A group of Navajo men sing with him while he prepares the traditional painting for the ritual. The patient usually sat in the center of the painting. The painting is taken back up as part of the process to heal.

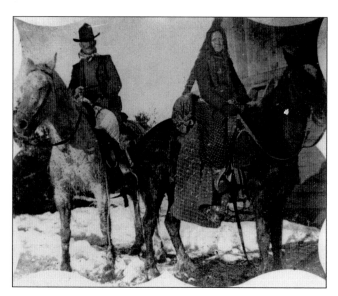

Henry A. Woods often accompanied his mother, Josephine ("Aunt Jody"), while she performed midwife duties in Bluff, Montezuma Creek, Verdure, or Monticello in 1896. She recorded births in her journal of births. According to her journal, all of the births she delivered were healthy and successful. She said she never lost a mother or child. Some children grew up believing that Aunt Jody carried new babies in her little black bag. She died in 1909 in Monticello and was buried on Bluff's Cemetery Hill. Her husband, Samuel, died one year later.

Blanding's Church of Jesus Christ of Latter-day Saints was dedicated here in 1928. The small building with the bell tower was constructed as the first permanent church and used as the Relief Society building after the dedication of the new church. The money to finish the building came later.

Myrtle Palmer was the midwife in early Blanding. She delivered most of the babies in the community. They were born in their own homes.

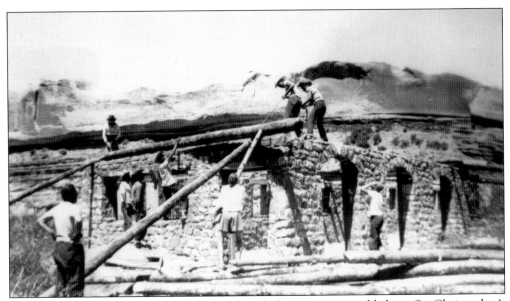

Fr. H. Baxter Leibler came to Bluff in 1943 with five persons, establishing St. Christopher's Episcopal Mission to the Indians. This photograph shows the church during the construction period, which was built by nearby Navajo workers.

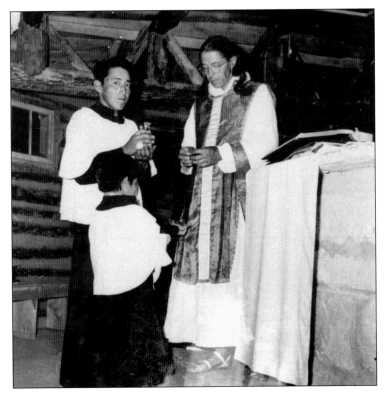

Father Leibler trained altar boys who were Navajo members of his congregation. In this picture, Ted Frank (in front) and John Billy Atcitty are assisting him. In later years, their first church burned down and a new one in the shape of a Navajo hogan was constructed.

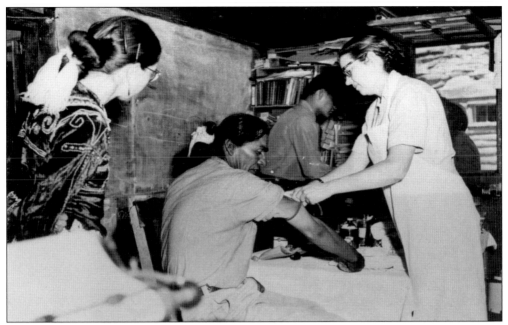

A medical center was maintained at the St. Christopher mission, with two nurses on staff. After first aid, most of their efforts were spent trying to get critical patients to hospitals for treatment, often for tuberculosis, which took the lives of about 80 percent of the Navajo patients in the Bluff area. Katherine Pickett, Nezzie, and a nurse are photographed about 1945.

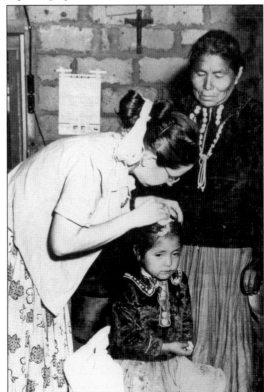

Katherine Pickett is treating an infection for a Navajo child in 1945 at the St. Christopher's Mission Clinic. Medical help was in such dire need when the mission was first established that they made the addition of a first-aid clinic their priority following the organization of a school for Navajo children.

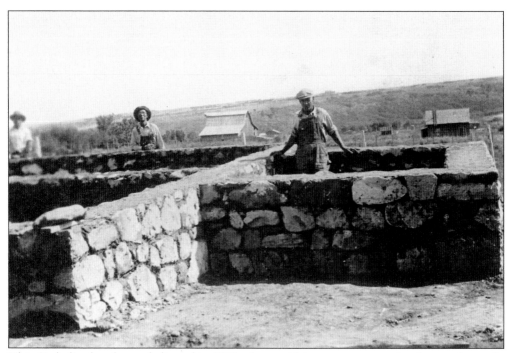

This Catholic church was dedicated in 1935, after parishioners spent years having services only when a priest traveled from out of the area to perform weddings or funerals. From the earliest years, however, there were faithful Catholics living in the Monticello area. As Monticello's Hispanic population tapered off about 1945, the Catholic population diminished.

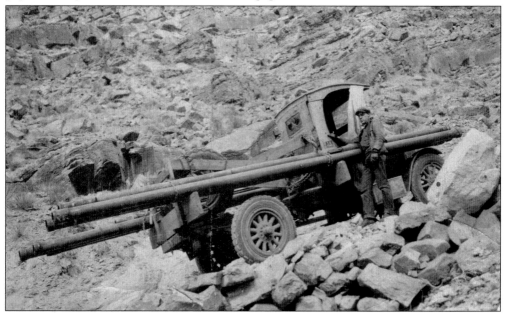

Lynn Lyman is pictured with the GMC truck headed for Soda Basin. This was the first truck owned by the Lyman Garage of Blanding, Utah. Lyman Trucking has continued until the present time under several different Lyman operators, providing freighting and mail deliveries for Blanding and surrounding communities.

Photographs of the Marie Ogden compound, during its early religious activity, are not found. Photographs of the church structure show the leaning cross against the ghost building of the commune. Marie Ogden brought religious members to San Juan County in 1938. She was the leader. The building had three stories. The oddly shaped shed on the left conceals an underground passageway to the basement. (Photograph by John F. Moore III.)

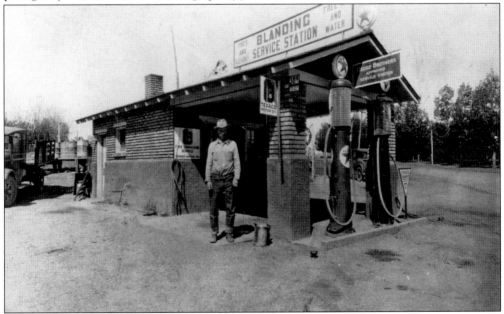

In 1929, Paul J. Black built this service station in Blanding, Utah. The truck behind the station is loaded with barrels of gasoline destined for southern sites. The year before, a man ran out of gas in Monticello. He had to hire a team and wagon to go to Grand Junction to buy gasoline, and haul it back to fuel his car before continuing. The ordeal lasted a week.

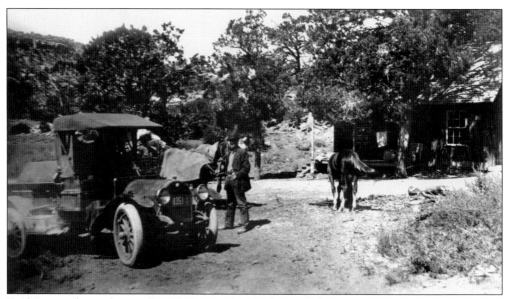

Fred Prewer drove this mail truck. It is parked in front of Skewer's home in Big Indian, where the mine is now. He took the mail contract to provide mail service from Moab to Monticello in 1906. The people who lived in Blanding began to get regular mail by 1914.

Citizens of Blanding built this fire station in 1934. The mounted fire hose was pulled by local citizens, who were in a big hurry. The other community's only answer to fire disasters was the standard bucket brigade.

Finished in 1912, this red brick church replaced the first log meetinghouse. It was built by members of the Church of Jesus Christ of Latter-day Saints, who were the original people to settle Monticello and Verdure. The group here is pictured following a church meeting about 1949. Most of the first settlers came from the parent community of Bluff, as they began to leave the fort.

The county seat was moved from Bluff to Monticello in 1895, but the courthouse was not built until 1920. Two rooms were ready to be occupied by 1922. By 1927, it boasted a public library, clerk's office, treasurer's office, assessor's office, public welfare office, district attorney's office, and two modern restrooms. It is still the courthouse today.

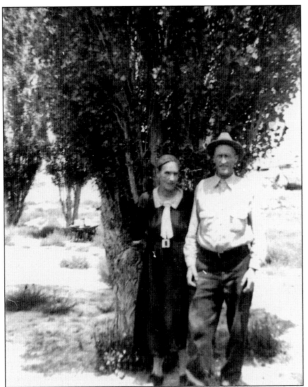

Eugene "Gene" and May Powell moved to Bluff, Utah, in December 1908 to become lifelong residents. Both are buried in the cemetery on Cemetery Hill. May became Bluff's midwife shortly after they arrived there. Her advice and skills were sought after in illness and tragedy, until county roads in the late 1930s allowed folks to travel to hospitals out of the area.

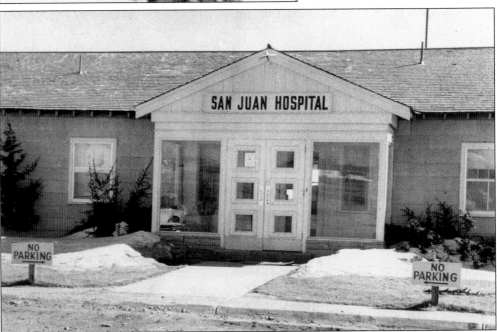

The San Juan County Hospital opened its doors in 1946, in Monticello, Utah. This was 67 years after the first pioneer wagons pulled into Bluff, making it possible for this author to have her babies in a hospital years later. Before remodeling, the building had served as a staff house for Vanadium Corporation of America, which was headquartered here.

Six

PIONEER SCHOOLS AND EARLY RECREATION

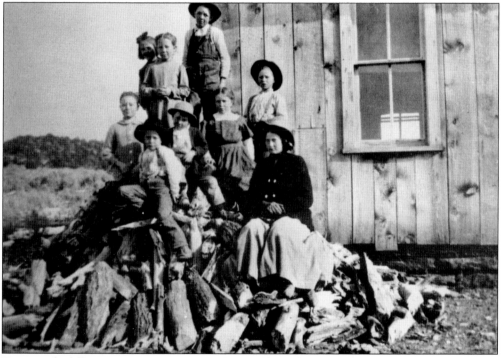

Two months following Kumen Jones's arrival in Bluff, legislative action declared San Juan a county and Kumen became the first superintendent of schools. He served two years, Joseph A. Lyman served for one, and Charles E. Walton served from 1883 until he moved to Monticello in 1888. Joseph F. Barton took the reins of leadership in the county education program and served five years. During that period, schools in both Bluff and Monticello operated under county funding. The students pictured are in front of the first La Sal school, which was built and funded by Fred Prewer in 1909. Isabella McCollum is seated on the right, wearing a hat and dark coat. Alvin Prewer is on top of the woodpile, wearing a hat. Ruth Prewer is on the top left with a ribbon in her hair. Clem Christensen was the first schoolteacher. The Prewers boarded the schoolteachers. This was a one-room school, with all grades taught.

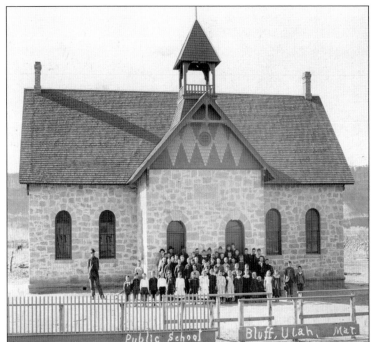

This new Bluff school building was photographed in May 1896. According to a record written in 1898, the two schools, Bluff and Monticello, enrolled 182 children. The average teaching salary was $45 for women and $55 for men. The school was built with sandstone blocks cut from the nearby cliffs and lumber that was sawed at Verdure.

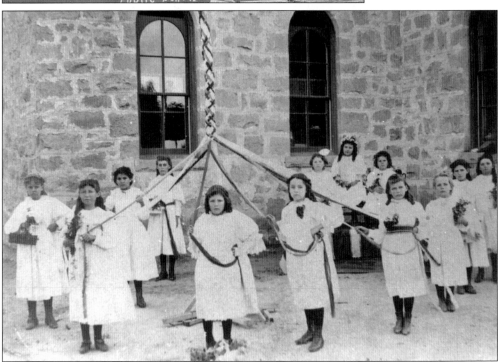

The girls of the school are weaving the maypole. The May Day queen (in the back corner) is Elizabeth Wood (Halls) with attendants Caroline Bayles (Raile) and Isabelle Barton (Wood). Pictured from left to right are Edith Redd, Emma Bayles, Josie Barton, Gertrude Decker, Elsie Butt, Sarah Perkins (Barton), Kisten Adams (Perkins), Ruth Perkins (Jones), Kate Wood (Hansen), and Beatrice Perkins (Nielson).

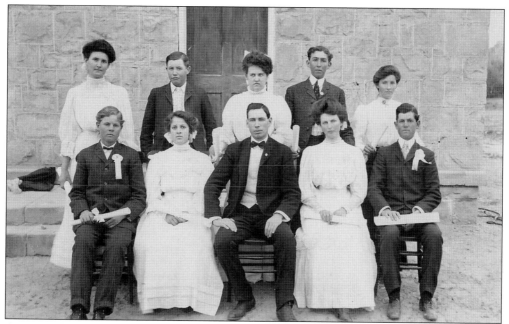

A very early Bluff graduating class, probably in 1910, poses here for their class picture. Pictured from left to right are (first row) Charlie Redd, Carlie Redd (Shurtliff), Dave Evans (teacher), Kisten Adams (Perkins), and Marvin Jones; (second row) Lizzie Woods (Halls), Leonard Jones, Ethel Nielson, Elmer Decker, and Gladys Perkins (Lyman).

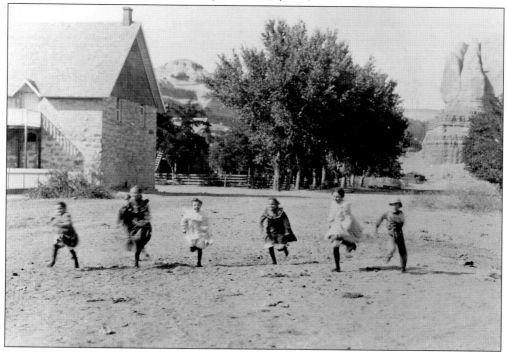

A children's race in progress in 1905 features, from left to right, Irene Perkins, Carlie Adams, Myrtle Adams, Zella Hyde, Florence Adams, and Herbert Hyde. Foot racing was held at most occasions and celebrations. It attracted participants of all ages. It was often the sport played at recess.

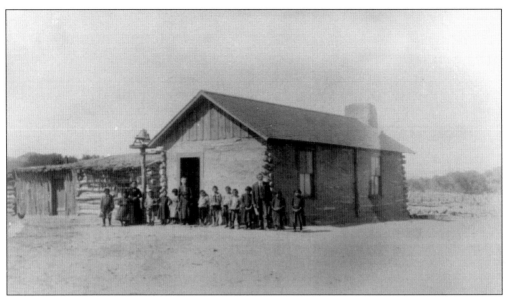

Howard Ray Antes in Aneth, Utah, built this independent Methodist school in 1901 for the Navajo children. He was called Hosteen Damiiigo, which means "Sunday man." Antes considered himself an advocate between government agencies and the Navajos. He often conflicted with the San Juan County government agencies, and he insisted the Navajos had rights to the north side of the river.

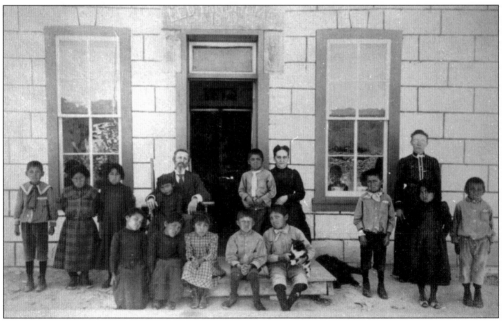

Howard Ray Antes and his wife, Eva, are pictured in 1901 on each side of the door with their Navajo students. Some Navajos wanted their children to go to school and learn; however, in this same area, there were hostile Navajo leaders who taught that it was evil for Navajo children to attend the Anglo schools.

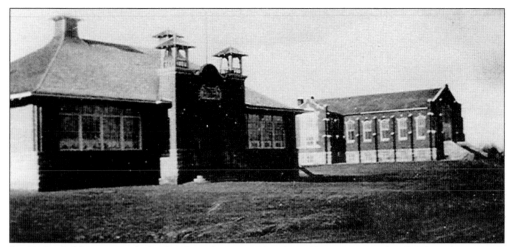

In 1913, children attended school in the new Blanding Elementary School. This photograph shows where it stood in proximity to the Blanding South Chapel. Louise Redd and Allie Hunter came from Salt Lake City to teach that fall. They were both 20 and were known around town as "the two old maid–school marms." They married local boys.

Blanding's first Boy Scouts of America troop was organized in 1916. Pictured here are those first members with their leader, George Hurst, standing by the horse. They are visiting Ruin Spring, south of town. The boys are not identified.

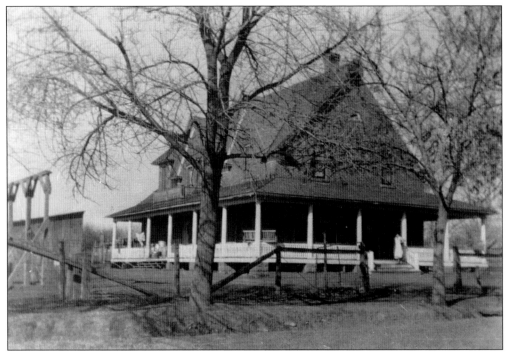

A Ute dormitory in Blanding was housed in this former residence built by Hansen D. Bayles and Evelyn Bayles. The Ute tribe paid to board native Ute children who lived in camps west of Blanding. The building was rented to the Utes by Evelyn Bayles in the 1930s. It has been restored to its former elegance and is the home of David and Nancy Kimmerle.

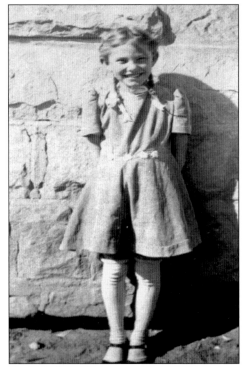

LaVerne Powell (Tate) is pictured here as a third-grade pupil at Bluff Elementary School in the fall of 1945. Girls were required to wear dresses to school. Tate wore long stockings secured by garters that her grandmother required her to wear for protection. Any illness was serious then. Clothes were washed on a board and ironed with flat irons. Bluff got electricity in 1957.

The Public Works Administration built the Navajo Mountain Day School at Navajo Mountain, Utah. After children finished the first and second grades, they were transferred to boarding schools. Today all students in all grades can go to school in their own community. There is a small high school there.

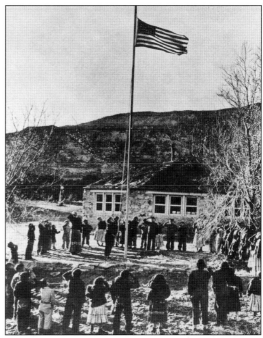

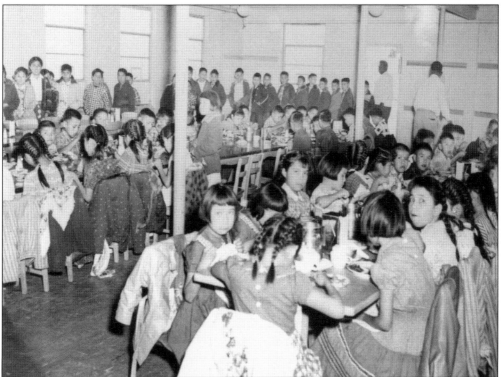

Children at the Aneth Boarding School in Aneth, Utah, are photographed having their lunch around 1944. Navajo people did not live in communities yet, so it was necessary to bring the children into living quarters to be able to obtain schooling. The government built this Bureau of Indian Affairs boarding school.

Shown here around 1920 is La Sal School after it was moved from the town site to a location near the store and post office. It was built in 1916 and served that area until about 1942. For a few years, La Sal had high school classes as well. High school students are now bused to Monticello.

Playing marbles was a common recess activity at most schools. Marbles had names; different games had names so were collected and hoarded as tokens of conquest. Pictured here at Blanding Elementary around 1941 are Kerry Shumway, Ernest Halliday, and Craig Redd.

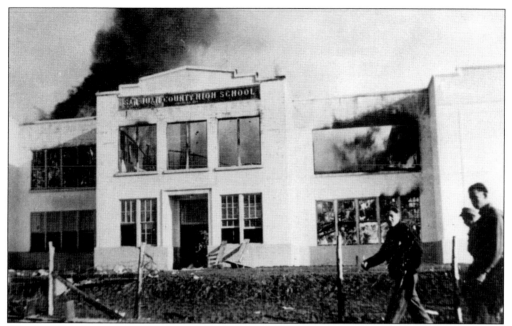

The first San Juan County High School was built in Blanding in 1937. On March 14, 1938, community members of Blanding woke to the sound of fire alarms. The school is pictured here burning on that day. Items from the ground floor, such as the books from the library, were thrown out a window and into the mud. One piano was lowered from the top floor to the ground below.

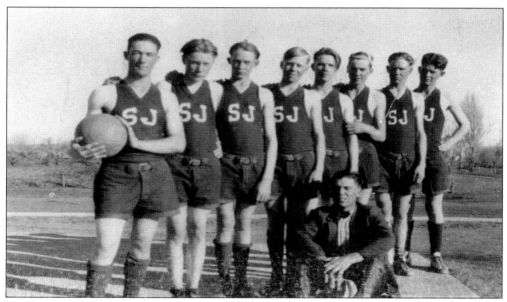

Members of this early high school basketball team from Blanding include, from left to right, Lawrence Palmer, Bud Black, Dave Guymon, Glen Black, Ashton Harris, Parker Hawkins, Kim Black, and Thell Black. George Hurst, coach, is sitting in front.

Taken in about 1926, this photograph shows the author's father, June Powell, mounted on the right, along with brothers Jay (center) and Frances. They often rode their horses to the Aneth trading post up the river. Their uncle Al worked in the Aneth trading post, which sometimes was a place to purchase a soda pop.

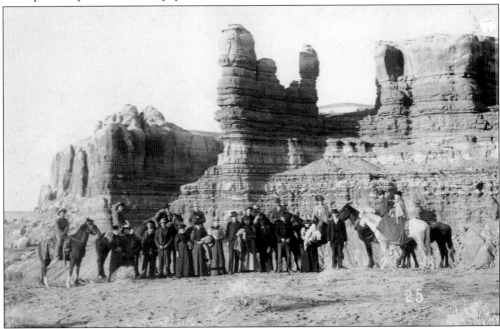

Horseback riding for adults, teenagers, and young adults was an enjoyable pastime in the scenic Bluff area and served as a break from the constant hard work of pioneer life. This group of men and women are posed in front of the Locomotive Rock on the outskirts of Bluff, Utah, in 1898.

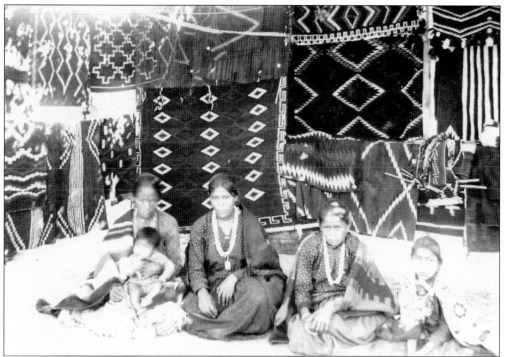

Navajo Jim Joe's wives are pictured here with two children at the Bluff Fair in 1910. The fair was organized for the Navajo women to display and sell their rugs that they had woven during the winter months. Displayed behind are the blankets of many weavers across the reservation and as far away as Shiprock. It was a festive time.

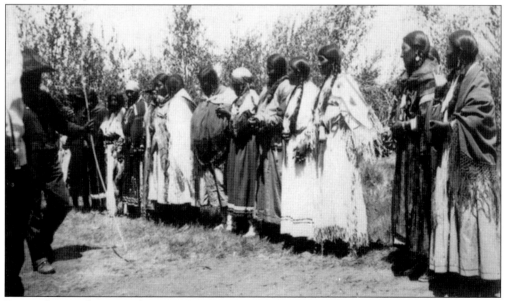

Pictured around 1929 is the annual White Mesa Bear Dance. Fringed shawls adorn the native dresses. The men line up on one side with women on the opposite. The music was created by a number of drums beat with a rasping instrument, by men, in their native custom. A lead man (shown with the stick) begins the nightlong festivity. He is one of the community's elders.

Picnics in Bluff were regular necessities in the spring and fall months to enjoy the cool breezes, which provided respite from the cookstoves stocked with wood. It would be 87 years, from its initial settlement, before Bluff would have electricity. The team and wagon await Minnie Larsen, Jennie Barton, and her brother John Larsen.

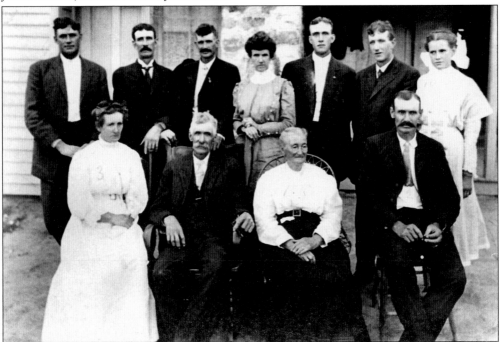

This picture was taken on the Ray homestead to celebrate the golden wedding anniversary of Thomas and Elizabeth Ray in 1909. The Rays were the first settlers in La Sal, and to celebrate 50 years of marriage was considered rare during pioneer times. They are seated in the center with son Cornelius, on the right.

Ozro Hunt is photographed while heading to his meetings at the church in the background. The Hunt family had a love for horses. They had horses that they matched for races at the occasions of Stake Conferences held at their church in Bluff. People from outlying towns gathered for conferences, funerals, and elections.

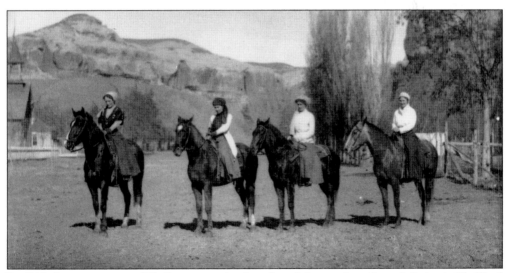

By 1910, the community of Bluff was more developed, and the number of people living in Bluff had grown. Pioneers depended on their horses, and they were very much prized and cared for, as shown by this fine group of young ladies. (Utah State Historical photograph used with permission.)

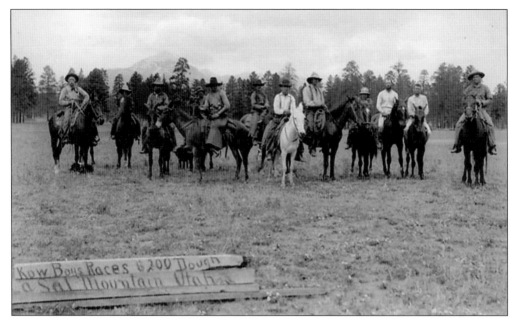

The Maxwells, McCartys, Rays, and others are pictured with their horses for a weekend of horse racing. Horse races in the La Sal area were advertised in advance to draw crowds from Colorado and other surrounding communities. Excitement was generated by the wagers set well in advance, which helped draw crowds in the 1920s.

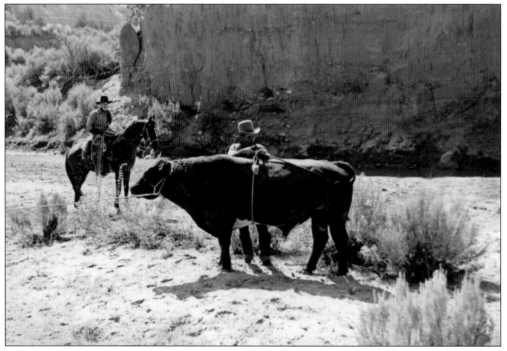

Ross Musselman (on horse) watches Cloyd Johnson prepare to ride the bull he has tied. Although the cattlemen had long days and weeks in the ranching business, they also created their own contests to liven up their days. A minor rodeo was a good break in the daily humdrum.

Chris Lingo Christensen drives his wife, Severena, and son to Moab for a special occasion. They settled in Monticello in 1897 into a two-room log cabin. Visiting friends and relatives in neighboring communities was usually tied to church occasions or holidays. (Utah State Historical Photograph.)

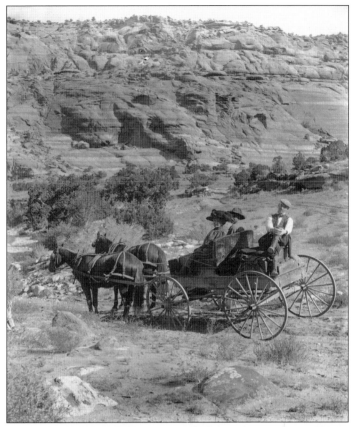

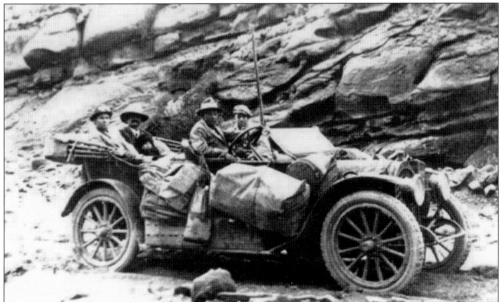

Taken in 1929, this photograph shows Charlie Redd driving friends up cow canyon heading for his community of La Sal. He has one bedroll over the front hood, one tied onto the side with two water bags, and a couple of large tarps. He is well equipped.

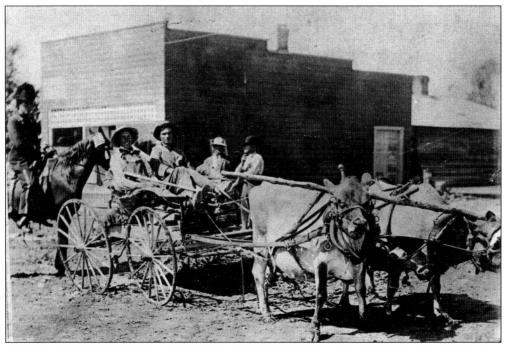

July 24 is Utah Pioneer Day, an official holiday in Utah that has always been celebrated in Monticello with a parade. This man has a couple of "oxen" yoked to pull his wagon.

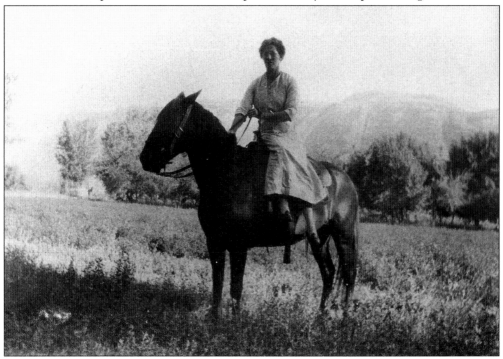

Mary Bronson Gordon is riding sidesaddle, as young women often did about 1907. She is photographed in Indian Creek, probably on the Carlisle range. She was married to the well-known "Latigo" Gordon, foreman of the early Carlisle Cattle Company. They lived in Monticello.

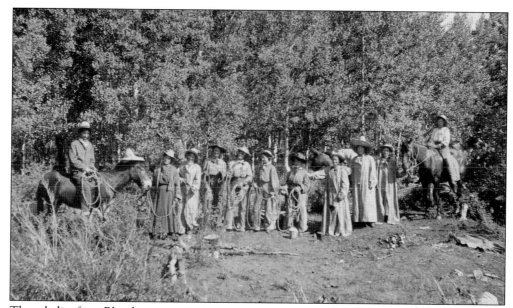

These ladies from Blanding are enjoying a summer outing on the mountain in a grove of aspens. A respite from the summer heat is always appreciated. The mounted lady on the left is Kisten Adams Perkins.

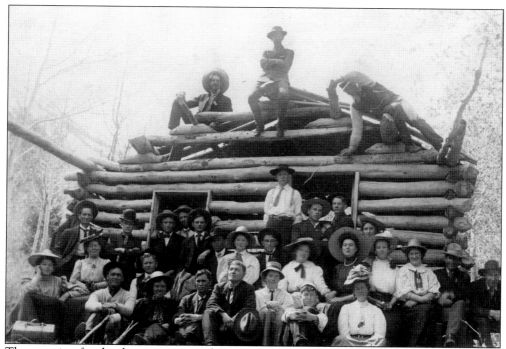

The occasion for the dressy outing at this mountain cabin is not known, but a happy group is posed for the camera. The man on the left in the first row is Corry Perkins, and the man on the left in the back row is his brother, George Perkins.

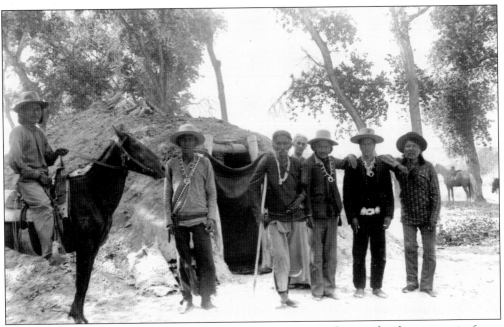

This Navajo home was the gathering place for the occasion of a sing for the patient in front. During this ritual, the men begin singing in the early evening. They sing all night while the medicine man does his traditional healing rituals. A squaw dance often goes on all night as well, yards away from the hogan. The singers are always men, and appropriate songs are chosen based on the type of healing the medicine man conducts.

This mound of dirt, out away from a community and in close proximity to Navajo hogans, is a sweat lodge in 1940. It functions as a place for social, physical, and spiritual cleansing. Operated much like a modern sauna, rocks are heated in an open fire outside, carried inside, and water is poured on them to create steam. Stripping, men sing, converse, and pray inside. Women use the sweat lodge, too, but not simultaneously with the men.

Seven

EARLIEST ESTABLISHED HOMES

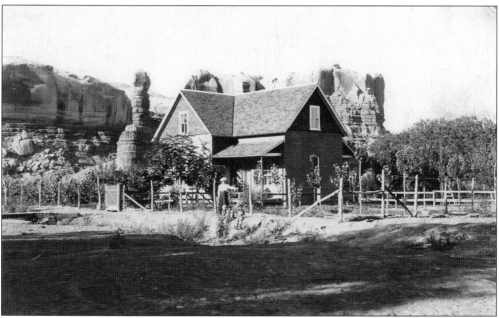

Following the leadership advice of Francis Hammond, the settlers went into cattle, sheep ranching, saw milling, and other employments necessary at the time. They depended on the river to water their garden plots. Prosperity came, and their homes and circumstances greatly improved. Roads were improved, and finer commodities were brought in. Francis and Leona Nielson, who moved to Monticello in 1908, built this brick home in Bluff in 1900. Eugene "Gene" and May Powell later bought this house and lived in it more than 40 years. Gene died in this home in 1942. This is the childhood home of author LaVerne Powell Tate. The home burned after the Powell family sold it. Gene ran his cattle with Kumen Jones and the Butt family near the Bears Ears.

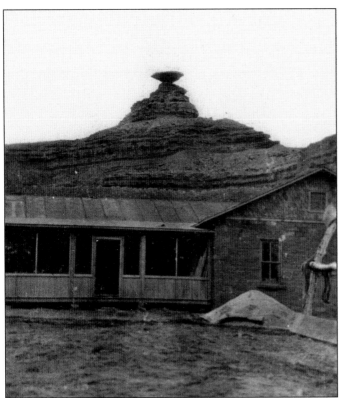

Adelbert Raplee and wife, Hattie, built their home near Mexican Hat on the site of their placer gold operation. It was destroyed by the San Juan River during a rampant flood in 1911. They moved to Bluff, where they lived the rest of their lives.

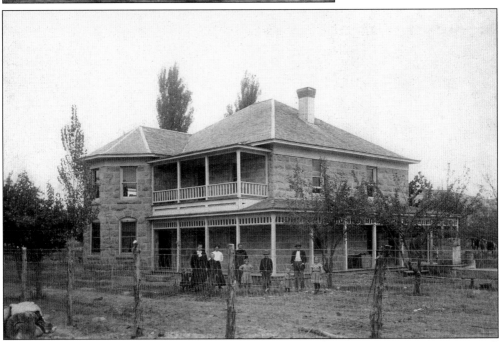

The rock home of John and Margaret Adams in Bluff is pictured here. From left to right are Pearl, Margaret, Melvin (in front of Margaret), Kisten, Caroline, Clara (in front of Caroline), Lloyd, Joseph (in dress), Ernest, and Effie. The San Juan River flood of 1911 also destroyed this home.

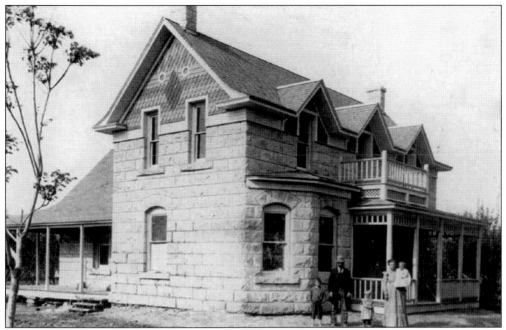

Lemuel Hardison, his wife, Elizabeth, and their young family pose beside their rock home built of local sandstone from Bluff, Utah. Uriah and Annie Butt also lived here with their young family for many years. Preserved through restoration, the building is still standing.

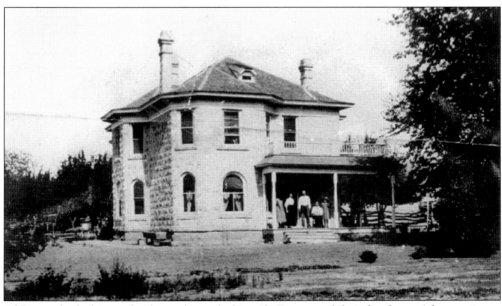

Al Scorup built this sturdy, elegant home for his wife, Emma, and their daughters. After moving to Moab, Freeman and Maggie Nielson reared a large family in the home, which still graces the entrance of Historic Bluff. It has also, in recent years, been restored closely to the original plan.

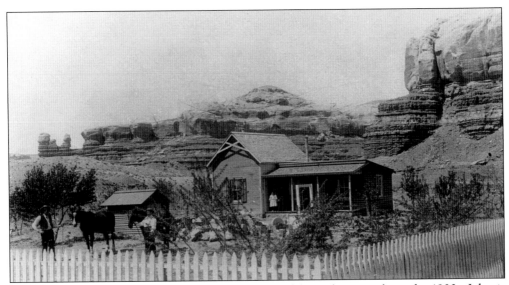

John and Minnie Larsen, of Bluff, built this brick-and-frame home early in the 1900s. John is pictured showing his horse, with Minnie and one of their daughters on their front porch. John was part of the Hole-in-the-Rock group. After being remodeled several different times, the structure is still standing.

Hyrum and Rachel Perkins built their sandstone home on the west side of Bluff, Utah. Hyrum began construction on it in about 1890 when the mission settlers were advised to "tough it out" in their remote outpost. Rachel was a very refined person.

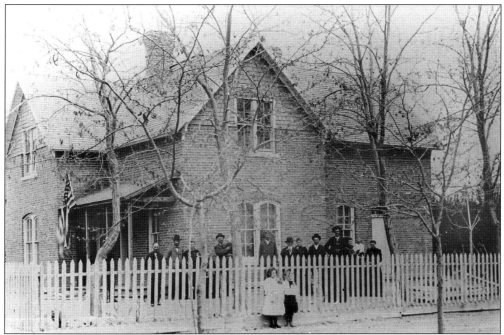

Called the Jens Nielson North home, this is the brick structure where Jens and Elsie's grandchildren loved to go. This family photograph includes children and grandchildren. Jens was the bishop of Bluff from 1880 until his death on April 24, 1906. Jens and Elsie are both buried at Bluff's Cemetery Hill. Gene and Mary Fouchee purchased the property then restored it.

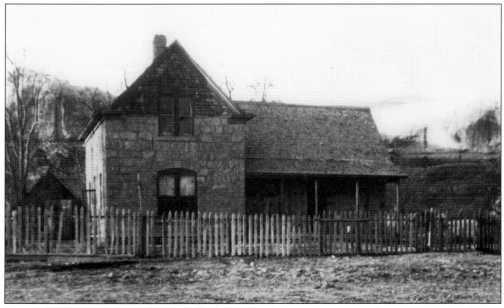

Jens and Kirsten Nielson's home (called the South home) was built from quarried sandstone excavated from the cliffs nearby. A descendant of theirs, La Rue and Carl Barton, own the beautifully restored heirloom, a half block from the original Bluff fort. The Jay Powell family lived in it during the early 1940s, and then Sister Boren, a German lady, lived in it for more than 25 years.

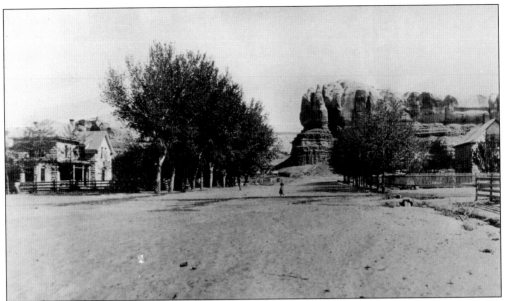

Looking toward Calf Canyon, the large, stone home of Hanson and Mary Ann Bayles, built in 1900, is visible on the left. Jens Nielsen's south home is on the right. This photograph demonstrates how wide and well planned the streets in Bluff are and the cleanliness of the pioneer community. The Bayles home was torn down long ago.

Kumen and Mary Jones built the first stone pioneer home outside the fort in 1894. It sheltered two families through the earliest pioneer times. After the Jones family moved out, the house succumbed to a fire in the later century.

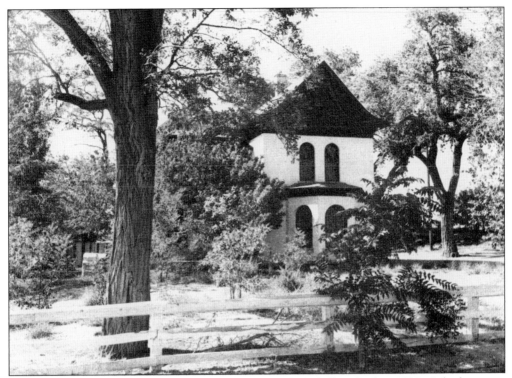

The James B. Decker home was built on the west end of Bluff in the late 1890s. It had a secret passageway that was meant to be utilized during Native American attacks. Several families lived here, but the Carlos Hall family lived in it during the 1940s and 1950s. It has been a useful dwelling and is now a stately bed-and-breakfast inn.

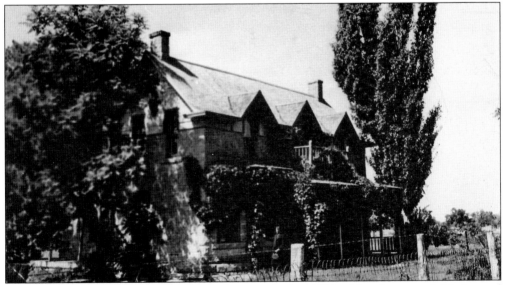

Wayne and Caroline Redd built this stone home in the late 1890s. After they moved, Marion and Ione Hunt purchased it. In 1939, the home burned. It stood on the east end of the block, where the elementary school is located today. They were the foster parents of Freeda Perkins Guymon, after her parents' death.

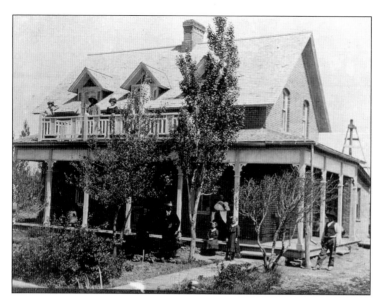

In 1895, Frederick I. Jones built the first brick home in Monticello. He and his wife reared 11 children and 4 grandchildren who lost their mother to a typhoid epidemic. Frederick was the LDS bishop for 25 years. In later years, the home served as a hotel and boardinghouse where rooms were rented for 50¢ a night. It has recently been restored.

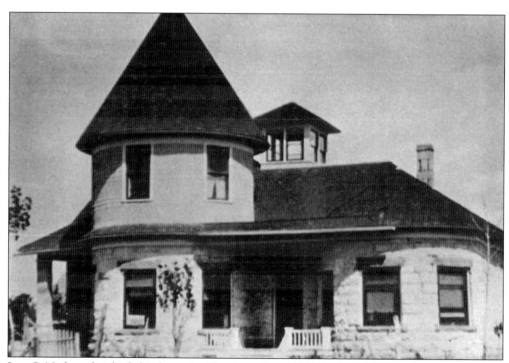

Jens P. Nielson finished this home in Blanding about 1910 for his wife, Martha Jane "Jennie." Jens P. came through the Hole-in-the-Rock with his parents when he was 18. Called the Castle House, it still resides in the center of Blanding. James and Karen Slavens have owned it for more than 35 years.

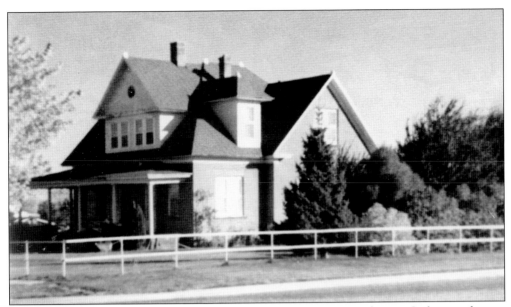

Lemuel and Lucy Redd built this stately edifice in Blanding. Lemeul was a Stake president in 1910 and served in that capacity until his death in 1923. Minnie Johnson owned it after the Redd family. She traveled and collected dolls and had a doll museum inside the home. Ben and Glenna Black reared their teenagers here and recently sold it. An elementary school is next door.

A patent for this home was granted to Lyman Nielson in 1907, and the home was built shortly after. Lyman died in the flu epidemic of 1918. The home was used as an isolation unit throughout those difficult times. Edd and Ida Nielson took ownership in 1920 and lived in the home until their deaths. Ida lived to be 100.

Construction of the Hyland Hotel began in 1920. It originally served as the home of Joseph H. Wood and his family. The original wood cookstove had two ovens. Fletcher Hammond's family bought it in 1924, and began its history of Monticello's Hotel. Ken and Beth Summers moved into it in 1936 and operated the hotel for years. The Summers family still owns the stately edifice.

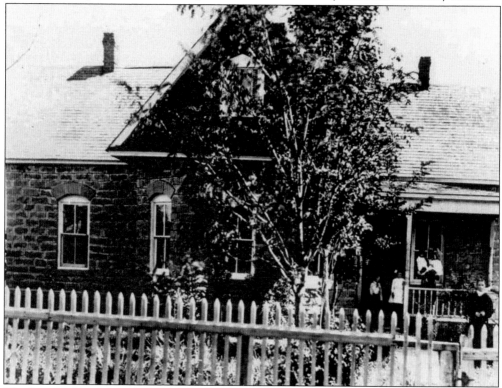

This beautiful home was built for Ben and Mary Ann Perkins after they moved to Monticello in 1891. After Mary Ann's death, Sarah Perkins lived here until her home was finished. Ben and Mary Ann were Hole-in-the-Rock pioneer settlers, first of Bluff then Monticello.

Eight

LANDMARKS AND SCENIC ATTRACTIONS

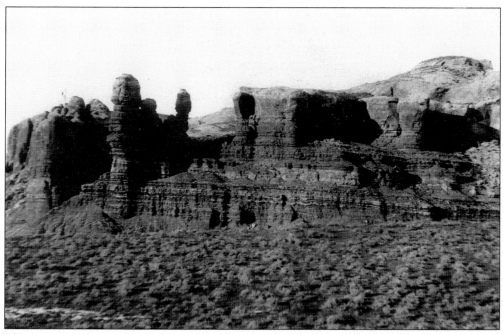

The erosion of the sandstone canyons and mesas eons ago in San Juan County created a natural wonderland that people travel from the far corners of the earth to be able to view. Water, wind, blowing dust, and elements of the sun and moon all combined in the vastness of these creations. Civilizations dating back as far as 1300 AD also contribute to the awe, as visitors stare into their abandoned stone dwellings and try to visualize what caused the mass evacuations that left pots seemingly in fire circles and sitting in the rooms as though abandoned in haste or death. The Locomotive Rock keeps its silent watch while guarding the west side of Bluff valley.

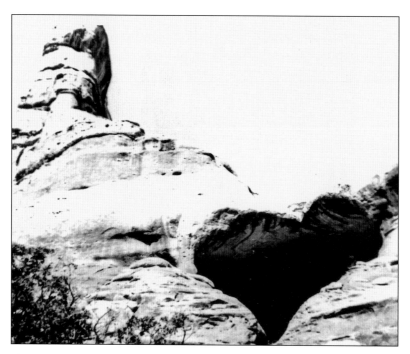

Cattlemen discovered Sacred Heart Cove in Canyonlands while they looked for stray cows. Canyonlands' rugged canyons and unique terrains attract visitors, such as rock climbers and river runners.

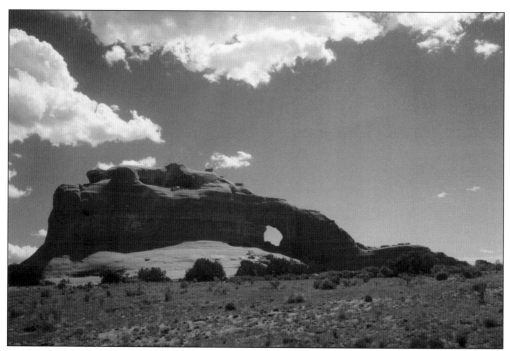

Looking Glass Arch rises above the sagebrush plain and serves as a reminder to La Sal residents of the pioneering struggles of the town's founders. Homesteaders, ranchers, and a few outlaws have raced past its window, often looking for water.

Twin Rocks is sometimes called Navajo Twins because the topknot of the right one resembles the Navajo *chinog*. The formation stands in the heart of Bluff and is located a block away from the author's childhood home. This is a popular site to locals and tourists.

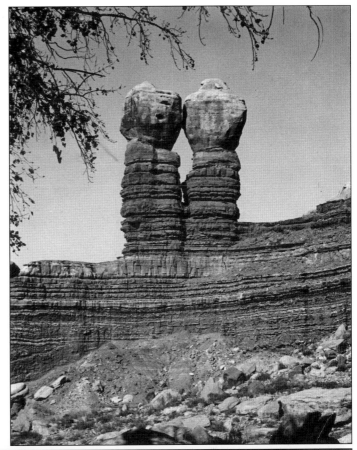

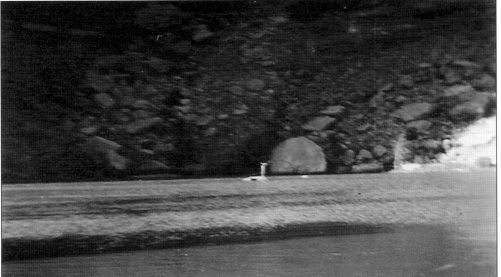

As a child, the author climbed cliffs, dived off the big rock at the old Bluff swimming hole, and picked cliff flowers. As better roads and vehicles became available, many San Juan County families traveled to the Bluff swimming hole, which is fed by an artesian well.

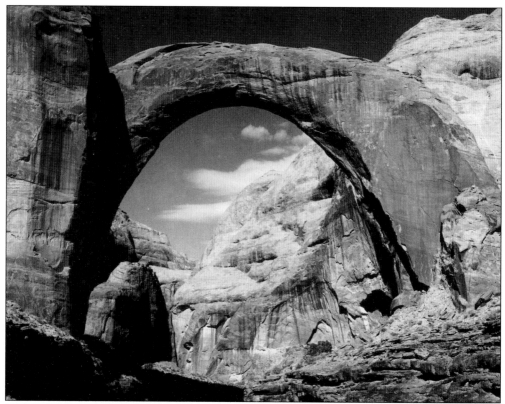

Early experienced explorers were the only ones to view the Rainbow Bridge because its location was difficult to navigate. Now one can take a leisurely boat trip on Lake Powell up to Forbidden Canyon and walk a short trail to the awesome span. It is a sacred Piaute prayer site. It was the local Piaute Jim Mike who escorted the early explorers to see it for the first time, in 1909.

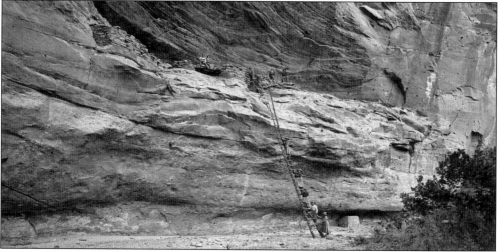

Pioneers discovered the habitations of ancient civilizations near the sandstone canyons of San Juan. This ruin, called Balcony House, is in White Canyon. Long dresses or not, the ladies wanted to see the unusual dwelling on this trip in 1898. The ladder, a relic from the past, was used by the original inhabitants.

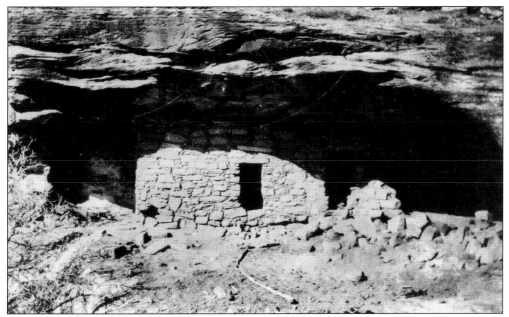

Ruin at "Crack in the Rock" is in Recapture Canyon. Charles Goodman hiked the canyons to photograph these habitations built about 1300 AD. There are actually ruins of other civilizations that have been dated back to 1100 AD. Old Spanish explorers' trails and artifacts have been discovered in Recapture Canyon.

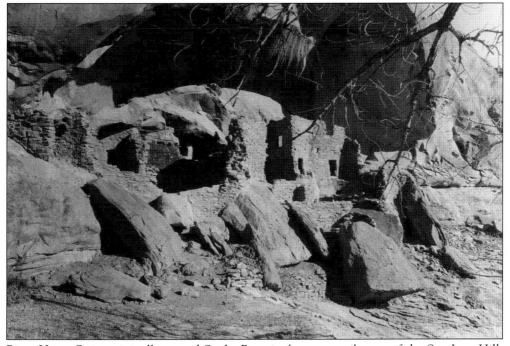

River House Ruin, originally named Snake Run, is about one mile east of the San Juan Hill, which the pioneers had to master. It might have been the first ruin they were able to explore that first year, as it was close to where the pioneers built the roads before they could travel into Bluff in 1880.

Visitors from the East can observe the icon of the Horsehead in Monticello. It is visible below the second peak, from the North. It is the usual logo of Monticello residents.

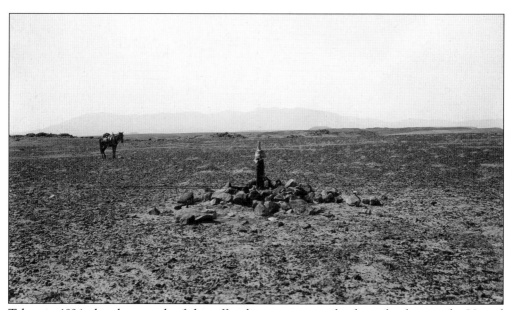

Taken in 1894, the photograph of this official monument marks the only place in the United States where four states meet. Today it is within the Navajo Nation Tribal Park, and people travel to have their photograph taken reposing, in some way, in four states at the same time.

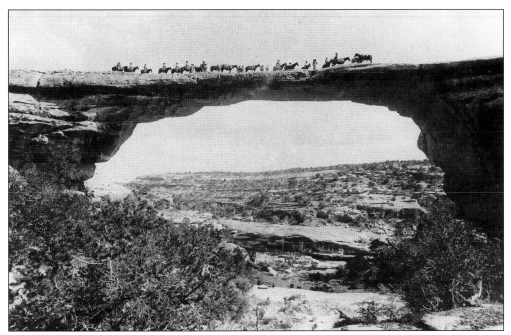

The above photograph is of Owachomo Bridge, when it was called Edwin. This shot, taken by Charles Goodman, was published in *National Geographic* magazine in 1904. The photograph helped promote the bridge, and in 1908 national lawmakers eventually turned the spot into Utah's first national park.

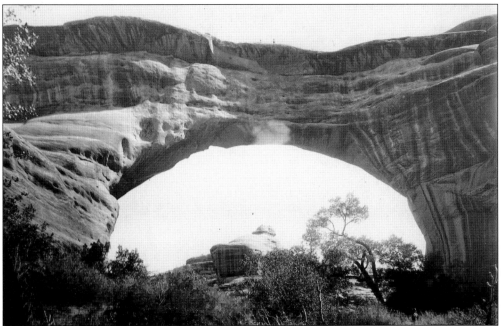

The Sipapu Bridge is also in the Natural Bridges complex. The third bridge is called Kachina. One can hike the whole length of Armstrong Canyon to where it enters White Canyon and see Horse Collar Ruins and observe the bridges close up. All are observed from the visitors parking lots situated in proximity to each for this purpose.

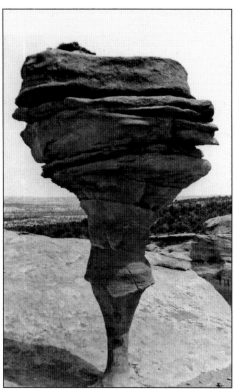

The Goblet of Venus used to stand along the trail from Blanding to the Natural Bridges when there was only a horse trail out there. When the roads improved and the uranium mines opened up, passersby would shoot at the statue's narrow neck until finally toppled.

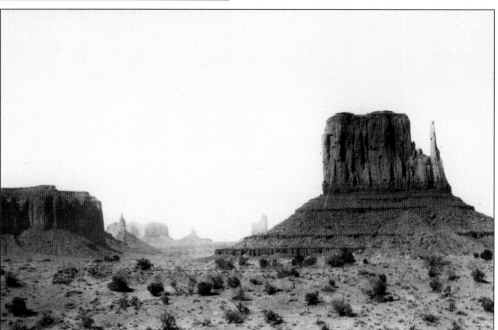

Pictured is Monument Valley, Utah, where one can observe eroded sculptures carved out of a once-continuous layer of De Chelly sandstone, which was over the more easily eroded Organ Rock shale. The monuments are so large they can often be seen from distant viewpoints, such as Canyonlands and mountain plateaus.

Called Gibraltar House in this 1986 photograph when Charles Goodman rode his horse up Ruin Canyon, this unique structure is called Stronghold House today. The Square Tower group of ancient ruins in the Hovenweep National Monument is considered the center of a very large area of Anasazi ruins.

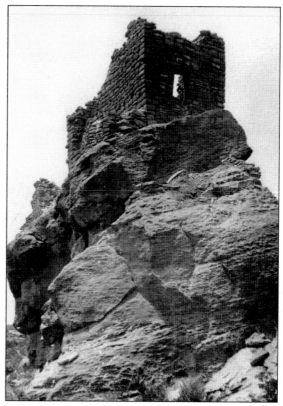

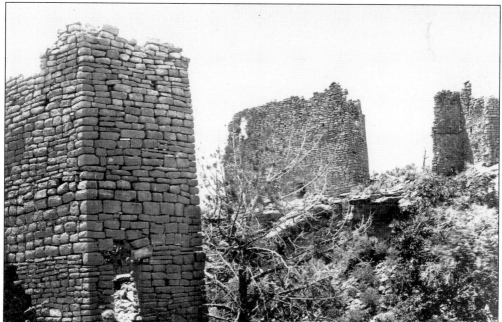

Labeled as cliff dweller ruins in Holly Canyon, this 1896 photograph shows the awe even the pioneers had for the vastness of Hovenweep, which means "deserted valley" in native dialects. The canyon name has been changed to Keeley, and this group of ruins is called Holly.

Albert R. Lyman built this Swallows Nest as a writing retreat in 1924. He is standing there about 1974. Within the walls of this humble dwelling, some of the finest stories of San Juan County history were written.

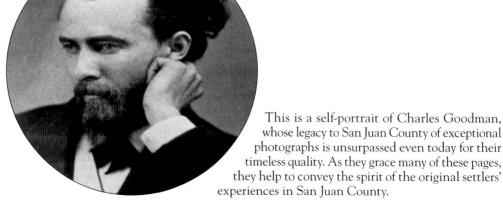

This is a self-portrait of Charles Goodman, whose legacy to San Juan County of exceptional photographs is unsurpassed even today for their timeless quality. As they grace many of these pages, they help to convey the spirit of the original settlers' experiences in San Juan County.